IMAGES
of America

THE LOST TOWNS OF THE QUABBIN VALLEY

IMAGES
of America

THE LOST TOWNS OF THE QUABBIN VALLEY

Elizabeth Peirce

ARCADIA

First published 2003
Reprinted 2004

Published by Arcadia Publishing,
Charleston SC, Chicago IL, Portsmouth NH, San Francisco CA

Printed in Great Britain

Library of Congress Catalog Card Number: 2003103945

For all general information, contact Arcadia Publishing:
Telephone 843-853-2070
Fax 843-853-0044
E-mail sales@arcadiapublishing.com
For customer service and orders:
Toll-free 1-888-313-2665

Visit us on the Internet at www.arcadiapublishing.com

CONTENTS

Acknowledgments 6

Introduction 7

1. Dana Revisited 9

2. Enfield Revisited 31

3. Greenwich Revisited 55

4. Prescott Revisited 81

5. New Salem Revisited 105

Postscript 123

ACKNOWLEDGMENTS

This book, a labor of love, is dedicated to the memory of those people who called the Quabbin Valley towns of Dana, Enfield, Greenwich, and Prescott their home. I wish to thank those who contributed ideas, time, and expertise as this book was being assembled. Thanks also go to Katherine Reed and Iva McKenney, both in their 90s, for sharing memories; to my daughter, who listened endlessly and patiently; to my son for his photographic skills; and especially to Betty-Sue Pratt, whose computer knowledge brought it all together. To all of these individuals, the compiler is deeply indebted.

—Elizabeth Peirce

INTRODUCTION

When a larger water supply was needed to serve the rapidly growing population of eastern Massachusetts c. 1900, the idea for the Quabbin Reservoir came into being. Engineers reasoned that by stopping the flow of the three branches of the Swift River that ran through the valley, like putting a plug in a bathtub, the water would be trapped in a huge basin and could then be discharged as needed. To accomplish this, all signs of human habitation would first need to be eradicated. The place where generations had trod, where families had been born, raised, and died is today covered by billions of gallons of pure, clean water and is surrounded by many acres of watershed to keep it that way.

This all came to pass by sacrificing the towns of Dana (incorporated in 1801), Enfield (1816), Greenwich (1754), and Prescott (1822). Parts of New Salem were also eradicated, although the town itself survived. The plan came into being during the Great Depression, and times were hard. Still, "All must leave" resounded through the valley as plans for the reservoir moved forward. The ultimatum was issued, token amounts of money were offered to the property owners, and the exodus began. Officials did not ask, "Where are you going?" or "What will you do for work?" On January 15, 1938, registered letters were sent to the remaining residents: "You are notified that the Metropolitan Water Supply Commission requires on April 1, 1938 the land and buildings now occupied by you."

As a result, some 2,500 people left their homeland, and 7,500 bodies from 13 cemeteries and other burial spots were exhumed and reinterred in the newly created Quabbin Park Cemetery. A few buildings were moved, but all others were razed, wrecked, or burned. Loam was removed, and all vegetation was cut, burned, or bulldozed. All that remained was a huge, sandy basin measuring 13 miles long by 6 miles wide. A large dam was built, and the new reservoir began filling in 1939. By 1946, the project was complete, and water could be delivered to cities and towns to the east through an elaborate system of tunnels and pipelines.

What was sacrificed? Gone are the sawmills, gristmills, and cloth mills. Gone are the factories where boxes, brooms, bricks and buttons, nails, pails, piano legs, carriage wheels, and hats were made. Gone are the mining of soapstone and the making of charcoal. Gone are the orchards with 50 varieties of apples, the berry fields, and the market gardens. Gone are the doctors, dentists, lawyers, statesmen, artists, poets, writers, musicians, photographers, inventors, educators, and, yes, patriots. Gone are the good times of the Grange, the neighborhood clubs,

singing schools, debating societies, husking bees, quilting parties, and taffy pulls. Gone are the private summer camps, the YMCA camp, and the Jewish Camp for Girls and Boys, and the "Rabbit Train" that connected the valley and provided transportation for students attending high school. The tenure of these towns did not go unnoticed. The sacrifice of these people is not forgotten; neither is the pastoral beauty of the Quabbin Valley as it was, and still is. A story about times that once were and can never be again is remembered and told over and over at the Swift River Valley Historical Society, where that story is frozen in time.

One
DANA REVISITED

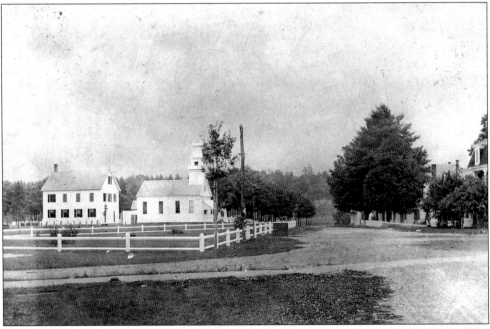

Dana was incorporated in 1801 and named for Chief Justice Francis Dana, who had helped the settlers in their struggle for incorporation. The coming of the railroad and the abundance of waterpower led to the building of factories where boxes, cloth, hats, soapstone, and charcoal were produced. Men and women found ample employment, and Dana was a lively community with large homes, a motorized fire department, electricity, a consolidated school, and the only Catholic church in the valley. Remnants of buildings that were moved from Dana and North Dana can be found in many places today.

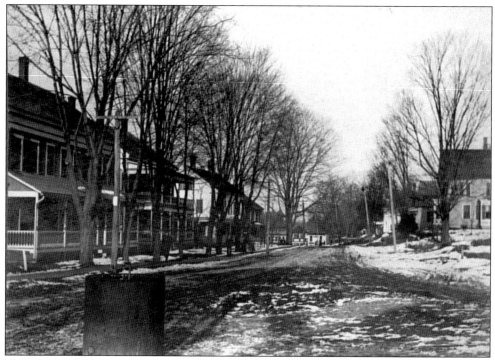

This photograph shows South Main Street in North Dana with a watering tub conveniently located for horses.

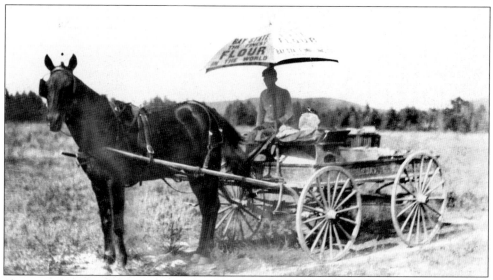

Shown in this photograph are Warren Doubleday and his grocery-delivery wagon. The cheese case and cheese knife from his store are on display at the Swift River Valley Historical Society.

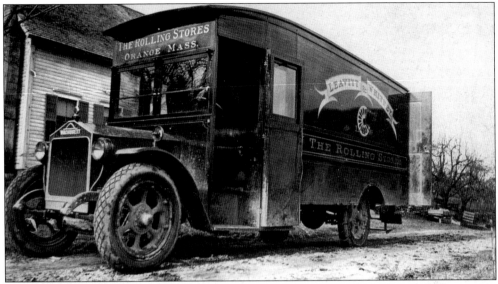

This "rolling store" from nearby Orange came through town each week and made stops at homes along the way.

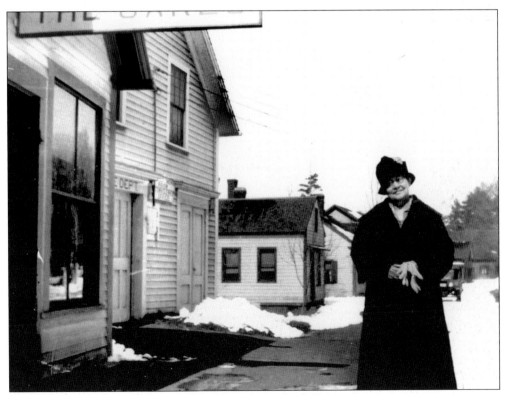

Grace Oakes was the proprietor of the drugstore in North Dana.

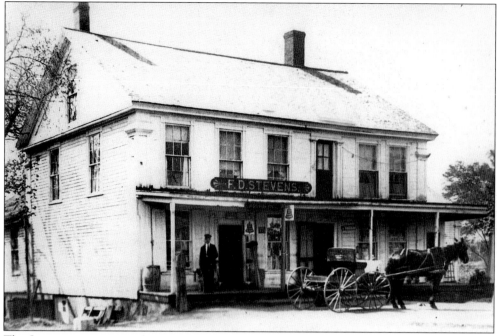

The Stevens store, in North Dana, carried a large variety of necessities for shoppers.

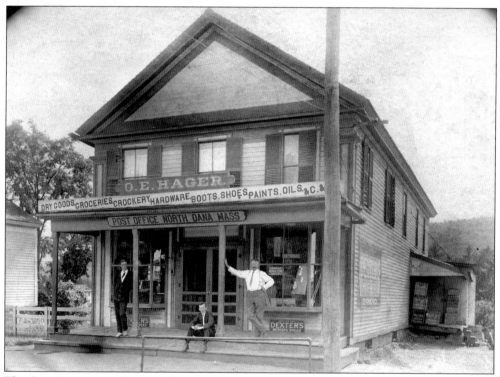

The Otis Hager store also served as the post office for North Dana. In 1846, a post office was established in Dana, which was then called Storrsville.

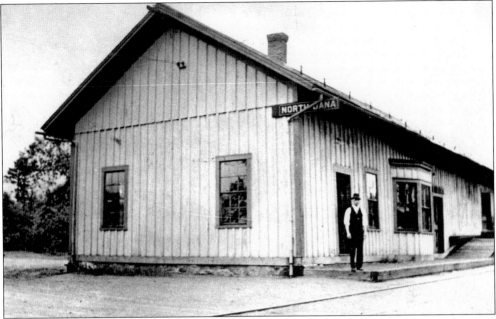

This photograph shows the North Dana railroad station. Each of the Quabbin Valley towns had a railroad station, all built along the same plan.

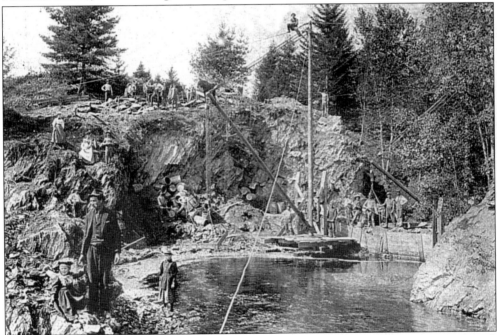

This photograph shows the soapstone quarry in North Dana. A naturally occurring soft rock made up mostly of talc, soapstone gets its name from its characteristically soapy feel. It cuts more easily than most rock and has a sheetlike form. A good insulator, soapstone is not affected by high heat, and it is commonly used for fireless cookers, laboratory tabletops, sinks, and laundry tubs. Pieces were used as bed warmers and foot warmers in the days before hot-water bottles or electric blankets.

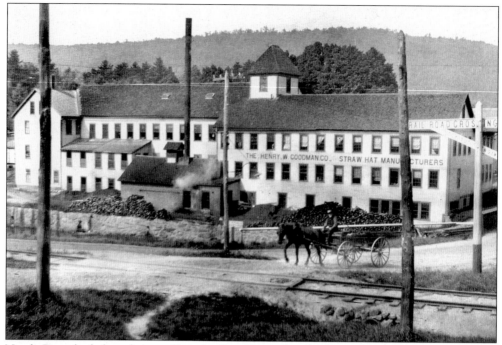

North Dana had three large mills—the Box Shop, the Shoddy Mill, and the Goodman hat factory (shown here).

The braiding of palm leaf hats became a cottage industry for women and girls. The basic hat was braided in the home and then collected for finishing in the hat factory. Palm leaves were imported from South America and brought to the home by horse and wagon. This picture shows Mr. Gowe on his rounds making deliveries and pickups. In later years, the shop made bonnets and top hats.

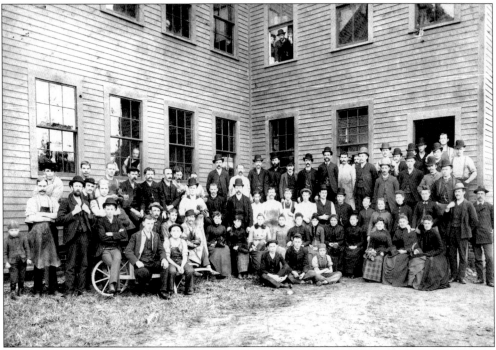

Men, women, and children (who were allowed to leave school and go to work at age 15) were employed in the hat shop. The palm leaf hats made here were sold all over the world, and samples of these hats can be seen today at the Swift River Valley Historical Society.

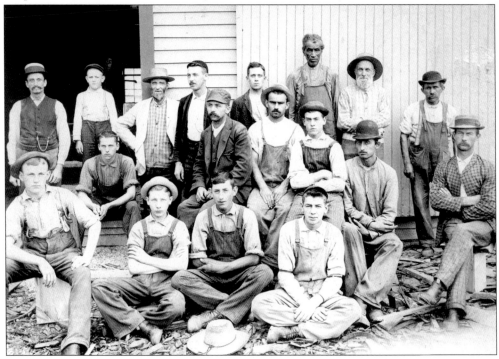

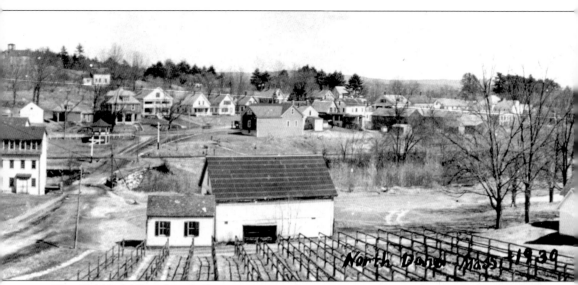

The Shoddy Mill in North Dana was an early practitioner of recycling. Rags and cast-off clothing were collected door-to-door and purchased by weight. Rags were sorted at the mill, processed, and then woven into new fabric. The fabric was used to make army blankets, army overcoats, and horse blankets. Across the road from the mill, you can see the racks where the fabric was placed to dry. A sample of this fabric can be seen at the Swift River Valley Historical Society.

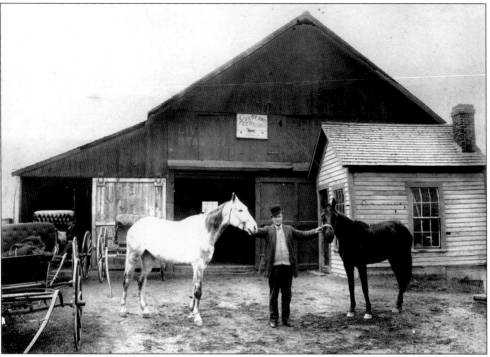

The taxi of today was the horse and buggy of yesterday. The "cab office" was the livery stable, where horses and carriages, along with a driver, could be hired.

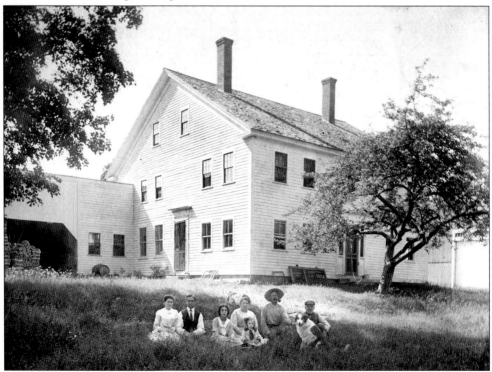

Shown here are unidentified occupants of the North Dana Center Town Farm.

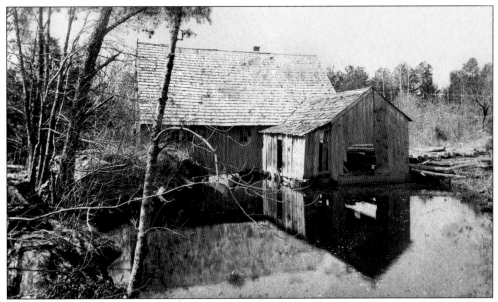

Several Doubleday families built their homes in a neighborhood cluster. Since streets were not named, this became known as Doubleday Village. Above is one of the mills owned and run by the Doubleday family.

Shown in this photograph is the home of Lewis Doubleday.

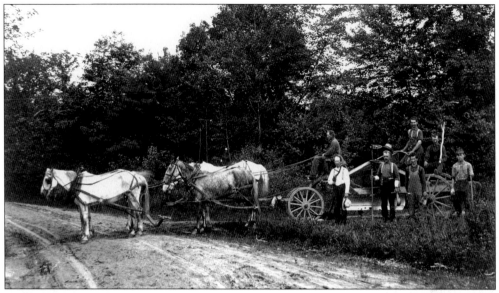

These farmers, their horses, and equipment are off for a day's work with what appears to be a grader used to smooth the roads.

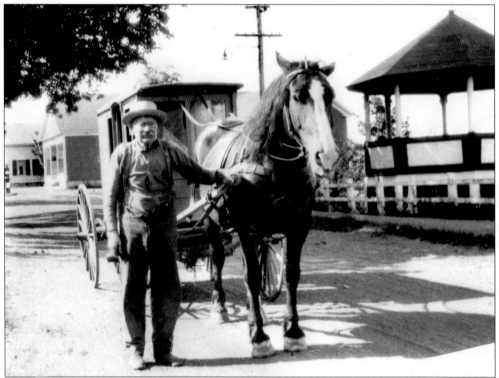

Edwin C. Matthews, known as the "singing milkman," was born in Quebec. He learned the blacksmith trade and also taught singing in the schools. Matthews came to North Dana in 1865 and operated a milk-delivery business. In his day, families would leave a bottle or pitcher on their doorstep, and Matthews would fill it on his early-morning rounds. When he stopped so his horse could drink, he sang.

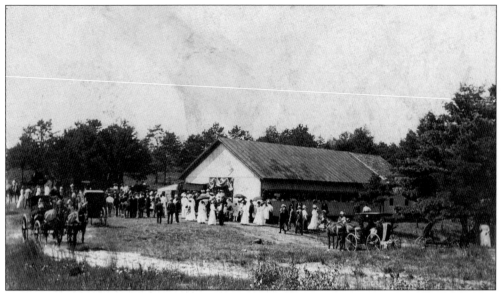

Tony Mason's Trotting Park was a popular place to show off your horses. This, along with racing bicycles, proved to be a popular pastime.

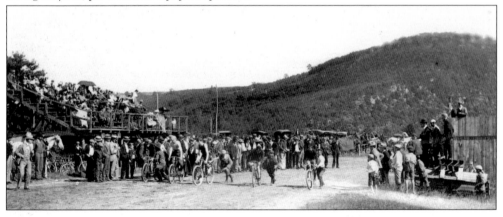

This picture shows a flock of turkeys ready to board the train and head to market. They were herded to the station in a flock and kept in a group with the help of a long whip. The schoolchildren were allowed to leave school to watch the proceedings.

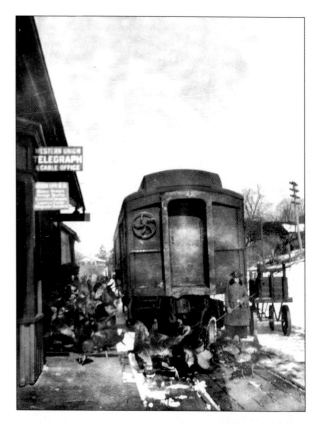

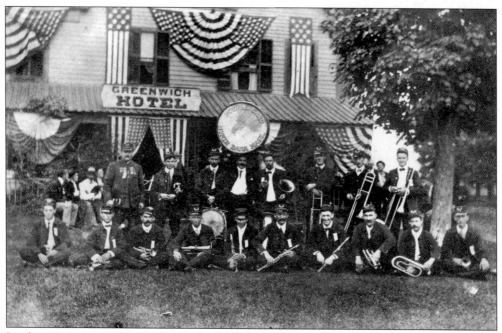

In this picture, the Mount L Band of North Dana has just presented a concert for the Greenwich anniversary celebration.

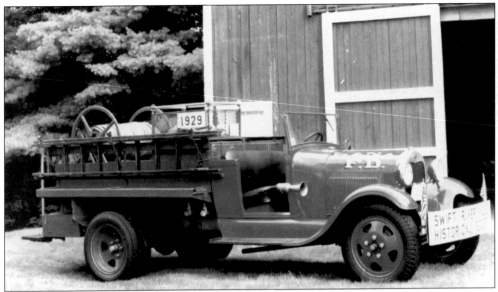

North Dana was the only town in the valley to have a motorized fire department. This vehicle, a 1929 Ford, is on display at the Swift River Valley Historical Society.

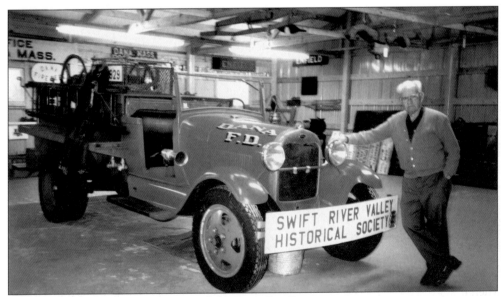

Bill O'Brien was the last fire captain of the Dana Fire Department.

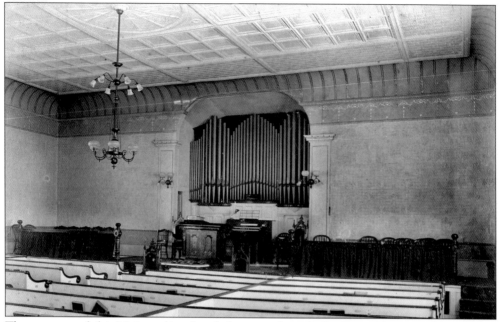

The memory of this Universalist church lives on through the Dana Vespers. This group of professional musicians performs free concerts throughout the area and is paid from a trust fund established by this church in 1938. Note the light fixtures in this picture. Originally lighted by gas, North Dana was the first town in the valley to enjoy electric lights. The power was produced at the site of an early sawmill, and lights had to be turned off at 7:00 p.m.

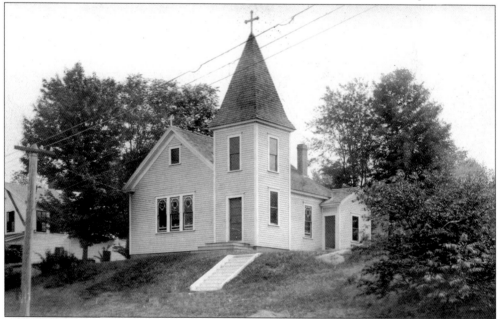

St. Ann's Church was the only Catholic church in the valley. Mr. Crawford of the Crawford Tyler Mills built it for his wife, Ann, who was an Irish immigrant. It was a mission church, and when it was dismantled, the organ, the hymnals, and the candlesticks were shipped to another mission church in Basutoland, South Africa.

This photograph shows the trees in the valley coated by a winter ice storm.

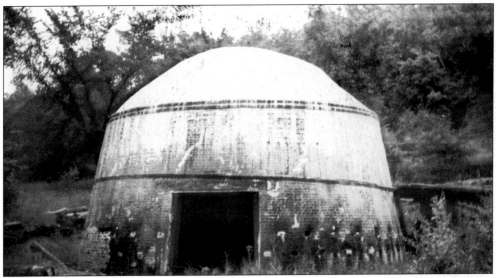

A large charcoal kiln on the Dana-Prescott line was built and operated by Billie Burke. To make charcoal, the structure was carefully stacked with wood, which was burned extremely slowly until only charcoal was left.

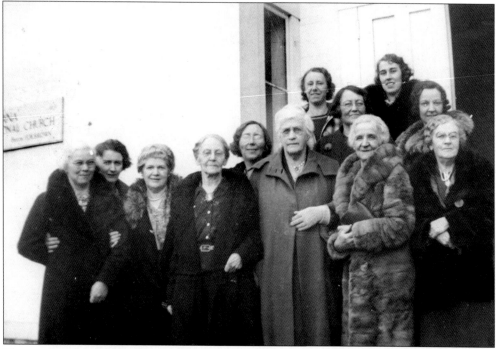

These members of the Ladies Aid Society had no problem finding service projects until 1938, when the community was no more.

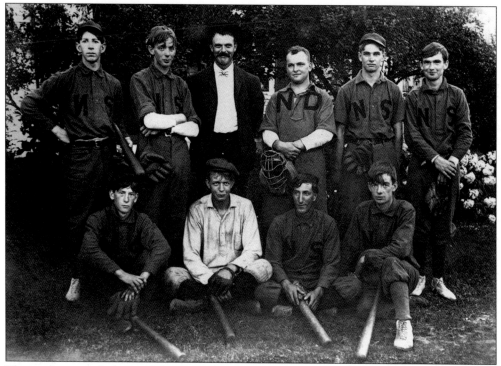

The uniforms and cleats of the Dana baseball team can be seen at the Swift River Valley Historical Society.

The grammar school in North Dana housed all the students of the town in one building. The "hot lunch" at school originated here under the supervision of teacher Helen Doane. Katherine Reed, a former pupil now in her 90s, tells about it: "It was usually soup and often potato soup. Us older girls were allowed to leave class a little early to peel the vegetables. It happened on Fridays, and all the students brought their own cup and spoon."

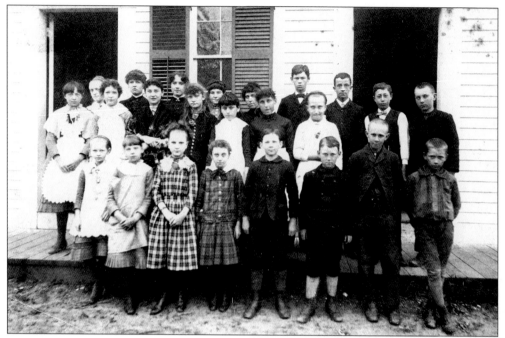

Ever-popular school pictures such as this tell us wonderful stories. This first group picture of unidentified students is dated 1886.

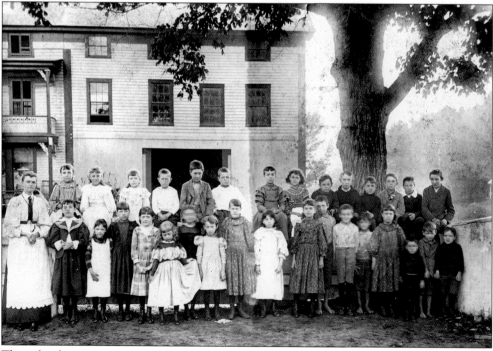

This school group poses in 1895.

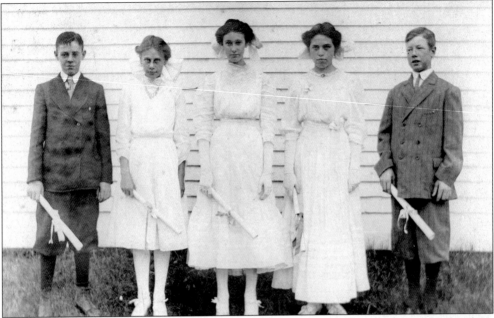

These eighth-grade graduates at the North Dana Grammar School in 1910 include William Larson, Leslie Cooley, Vera Bates, Mae Stone, and Myron Vaughn.

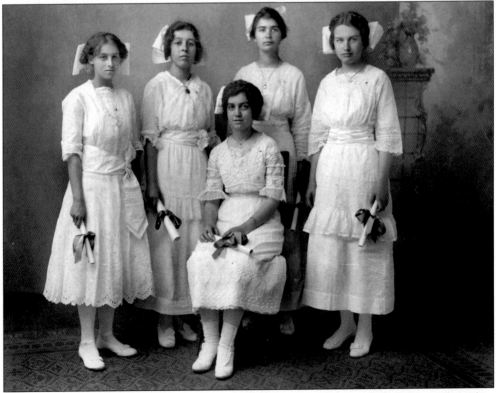

These young ladies dressed in white for their graduation in 1914 are, from left to right, Alice Towne, Agnes Dufrense, Mary Donovan (seated), Florence Ripley, and Irene Albee.

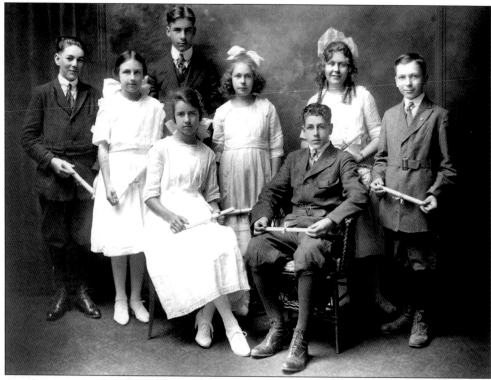

Another group of eighth-graders at their graduation in 1922 is ready to face the world.

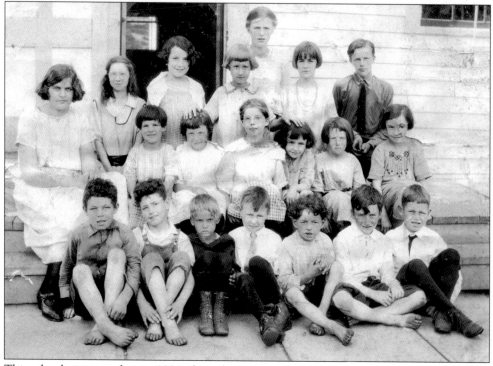

This school picture, taken in 1924, shows bare feet and smiling faces.

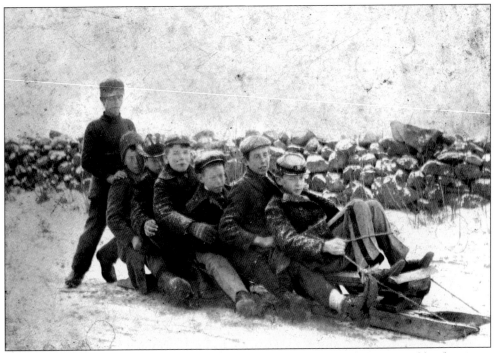

Wintertime did not always mean work; there was time for play, as demonstrated by this group of young men.

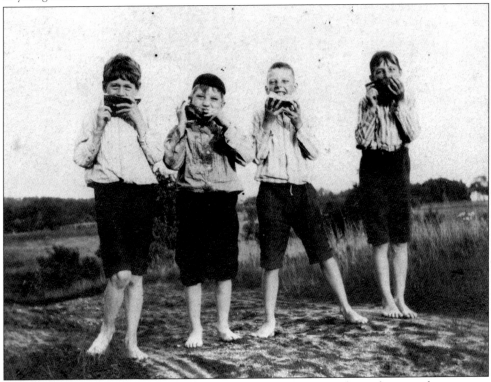

Summer fun was always in order. These youngsters are enjoying a feast of watermelon.

Two
ENFIELD REVISITED

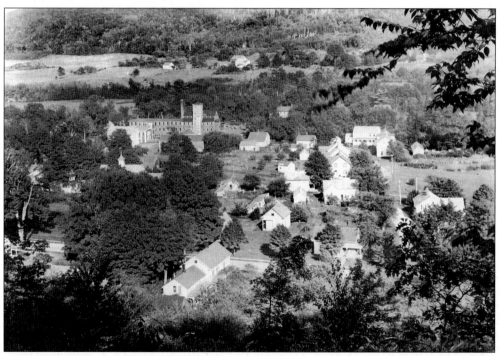

Enfield, the largest and wealthiest of the four submerged towns, was separated as a township from Greenwich in 1787, incorporated in 1816, and named for Robert Field, an early settler. Abundant waterpower from the two branches of the Swift River attracted many industries. The manufacture of cloth was a major industry in the section known as Smith's Village. During the destruction of the town and construction of the reservoir, many of the large homes were used for offices and laboratories until the project neared completion in 1938. Hence, Enfield was the last of the four towns to be demolished.

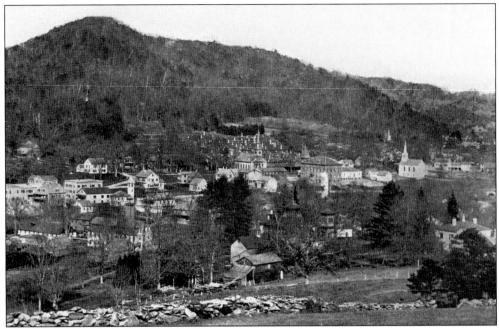

If the observer were at the lookout in the Quabbin Park Reservoir, he would be looking down on this area now deep beneath the Quabbin's waters. The site of the cemetery, visible in this picture, is now at the water's edge.

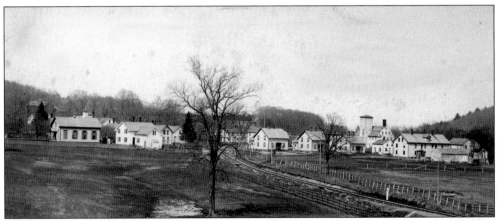

This cluster of buildings was in the section of Enfield known as Smith's Village. A large cloth-manufacturing business owned by Henry Martyn Smith was located here along with housing for employees.

Marion Smith, born in 1862, was the daughter of Henry Martyn Smith, wealthy owner of the Swift River Company. Smith was civic minded, influential, and very generous with her inherited wealth.

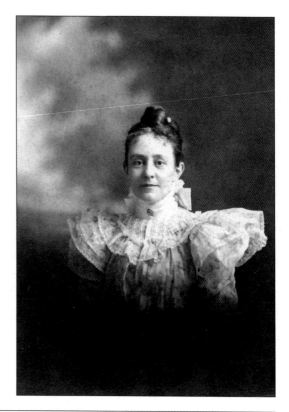

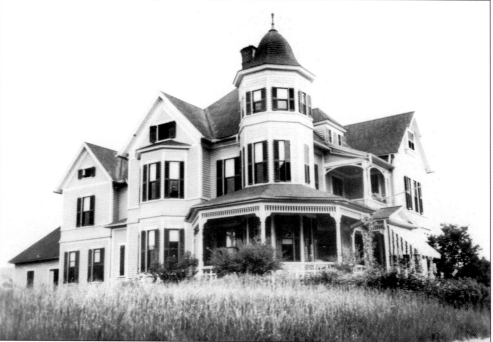

Pictured here is Marion Smith's home in Enfield. With the demise of the town, she moved to Ware, Massachusetts, and built an equally impressive home there.

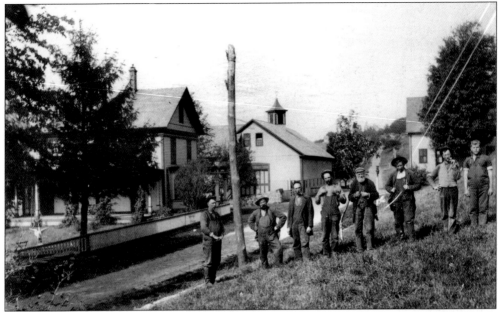

The Sherer farm was built in 1799 by C.T. Sherer, who owned clothing stores in Worcester. The farm was the scene of annual outings for Sherer's employees and their families, who were transported to the farm by special trains engaged by Sherer.

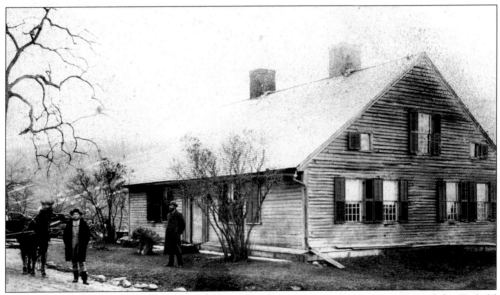

This is the early Enfield home of Rev. Joshua Crosby, who was the first minister of the Enfield Congregational Church. With the closing of the valley, the building was sold to President King of Amherst College and moved to its present location on the college campus.

The Hooker home was the ancestral home of Civil War general Joseph Hooker.

Pictured here is the home of Robert Field, for whom the town of Enfield was named. In 1938, this house was razed, numbered piece by piece, and reassembled in Dorset, Vermont, where it is a private home today. Some changes have been made since the house was reassembled, but it is still easily recognizable; the front entrance, for example, is original.

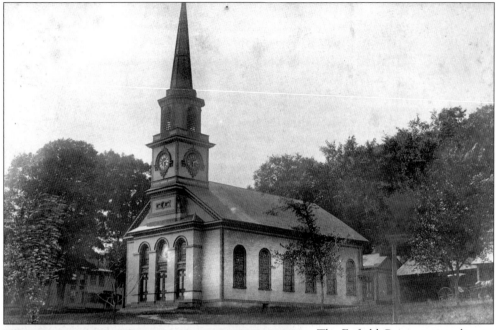

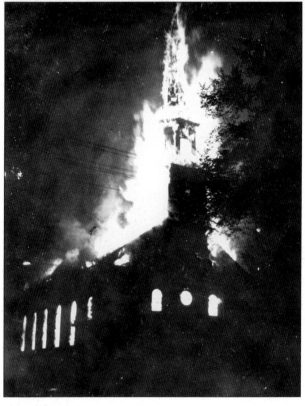

The Enfield Congregational Church, built in 1786, was scheduled to be demolished in 1936. Despite this, plans were made for an elaborate 150th-anniversary celebration. One week before the event, the church was mysteriously destroyed by a raging fire in such a traumatic event that it caused strong men to weep. The church bell crashed to the ground, and Marion Smith had the bell recast and mounted in the steeple of the New Salem Congregational Church. Small bells were made from the remaining metal of the original and sold as souvenirs. Stored in the parsonage away from the church, the communion set escaped destruction and is on display at the Swift River Valley Historical Society.

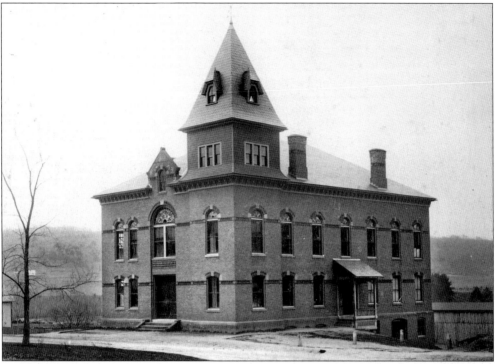

The Enfield Town Hall contained the "lockup" in its basement. The primary and grammar school rooms, the library, and selectmen's office were on the first floor, and the auditorium was on the second floor.

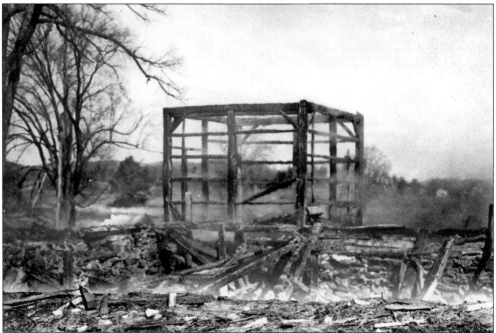

This photograph shows the still-smoking remains of an Enfield building. By 1938, all buildings were razed, wrecked, or burned to clear the valley of all evidence of human habitation.

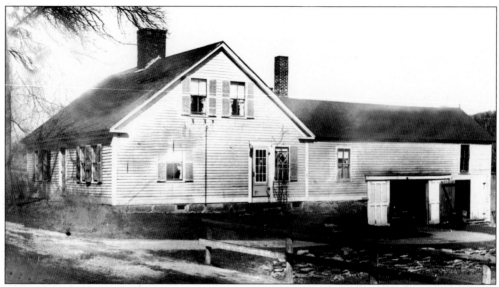

The first town meeting of Enfield was held here at the home of photographer Benjamin Harwood.

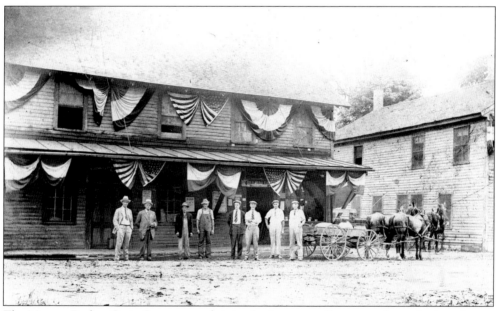

The Morgan Ryther Grain Store was a thriving business as well as a popular gathering place.

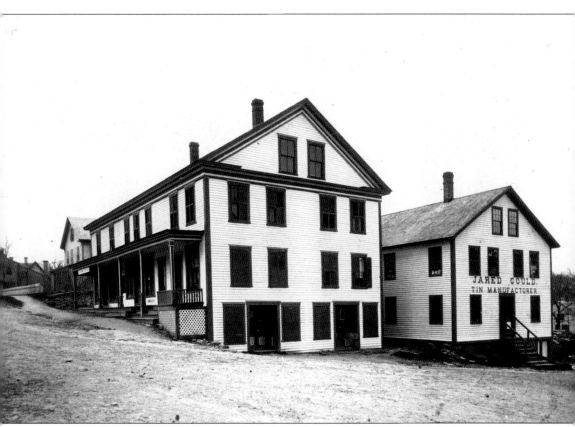

The tin-manufacturing shop of Jared Gould is shown here behind the Barlow Block. Gould had a monopoly on the tinsmith trade in the valley. Each week, he sent out 12 drivers, each with a team of horses hitched to a red wagon filled with wares. Their job was to return at the end of the week with empty wagons and full purses.

The Tebo Mill in Enfield made woolen goods. Seventy people were employed here by 1900.

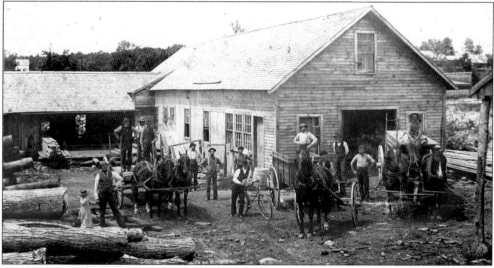

This photograph shows a large sawmill in Enfield.

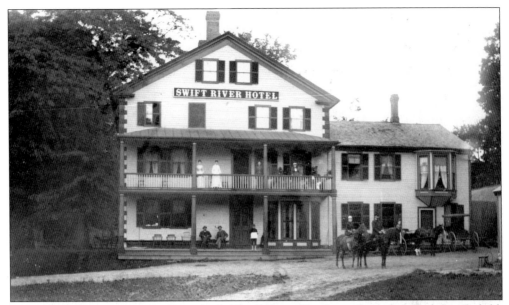

Located on the stage route to Boston, the Swift River Hotel was the only hostelry in Enfield. The hotel's huge, elaborate dining room could seat 300 guests, and the menu was equally elaborate. The Metropolitan District Commission made use of this facility until 1938, when it was razed and the lumber sold.

Merrick Howard was one of the early innkeepers of the Swift River Hotel.

41

Dr. Willard Segur, the much loved and trusted horse-and-buggy doctor from Enfield, traveled throughout the valley ministering to the sick for 40 years. Segur purchased his first two-cylinder automobile in 1905.

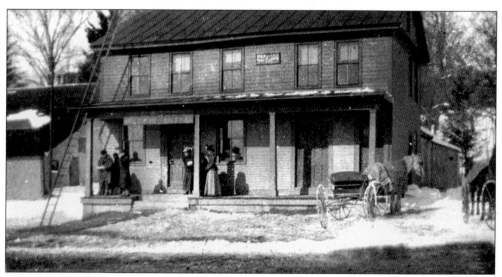

This photograph shows the building that housed Dr. Segur's first office.

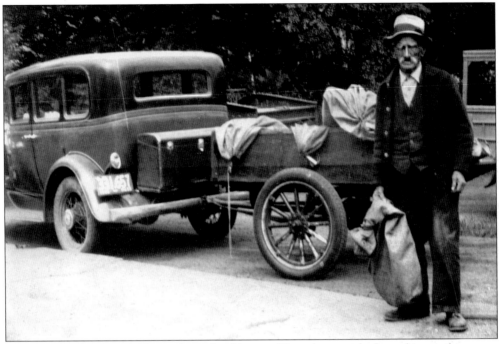

Patrick Rowan was Enfield's mailman for 64 years. This photograph shows him on his route, carrying mail from the train to the post office.

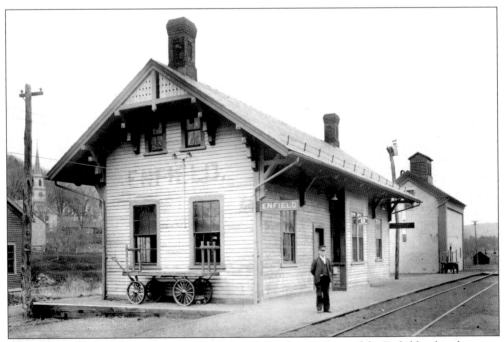

Albert Keroack, the last station agent in 1938, is shown here in front of the Enfield railroad station.

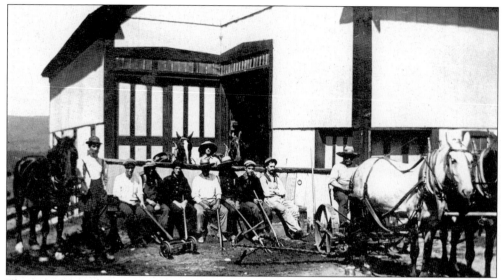

This crew seems to be prepared to clean the roadsides or perhaps the cemeteries.

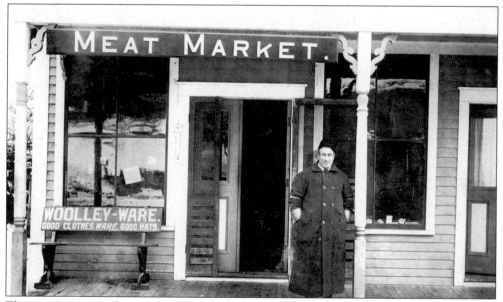

The town's meat market was located in the center of Enfield.

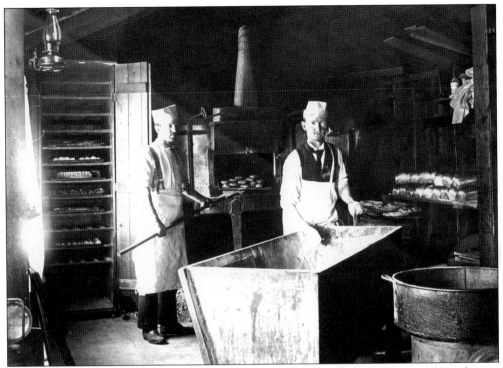

This photograph shows the Model Bakery in Enfield prior to 1903 with racks of bread, pies, cookies, and doughnuts made daily.

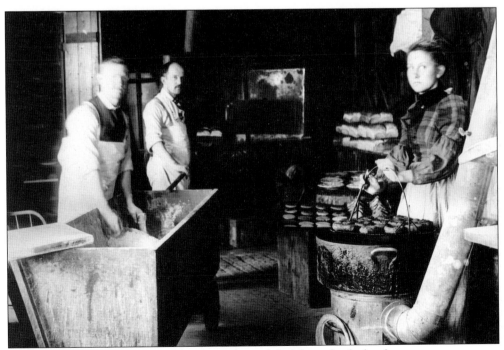

Pictured here is a fresh batch of doughnuts being lifted from the fry kettle.

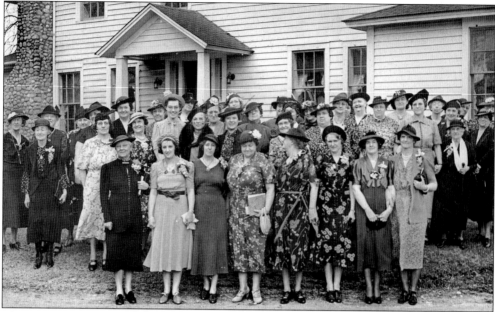

The Quabbin Club was a politically and socially active group of Enfield ladies who were not shy about taking a stand on issues of the day. The club was organized in 1897 and is shown here at their last meeting in 1938.

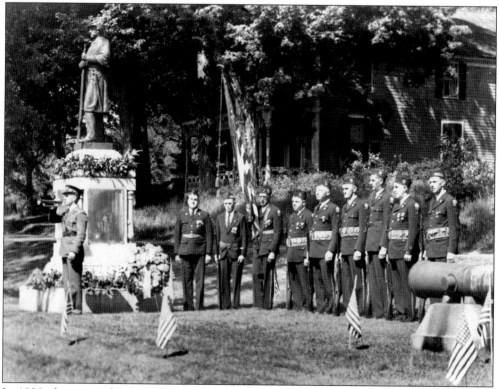

In 1938, the town of Enfield observed its final Memorial Day exercises. The monument seen here now stands in the Quabbin Park Cemetery.

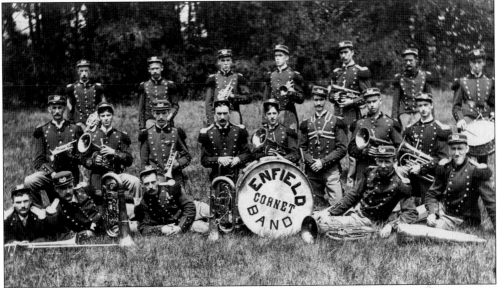

The Enfield Cornet Band shown in this photograph. Each town supported its own band.

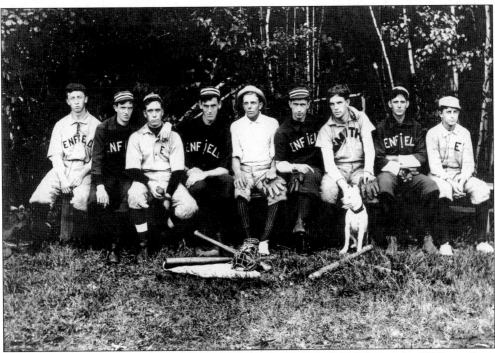

Shown in this photograph of Enfield's town baseball team are, from left to right, William Gray, James Metcalf, Richard Hickland, Thomas Rock, George Webber, Robert Metcalf, Samuel Ritchie, Fred Churchill, and Walter Johnston.

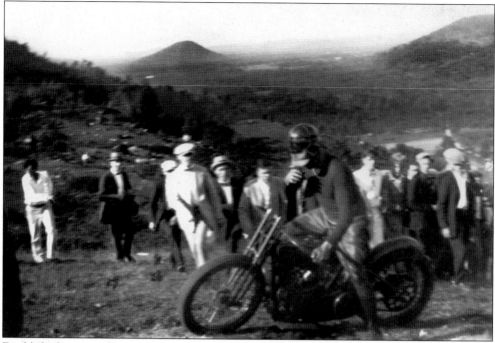

Established to see whose vehicle could make it to the top of the hill, the Hill Climb was an exciting event that drew large crowds of participants and spectators.

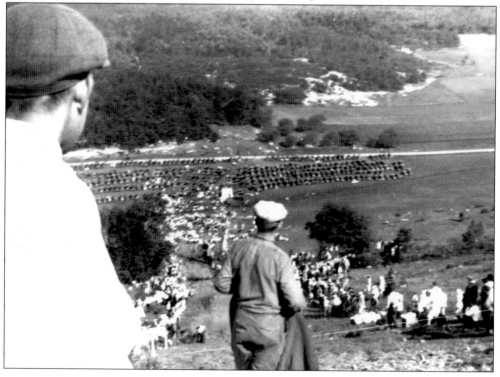

The beautiful baby shown here is Pearl Parker, born in Enfield in 1897.

The style of clothing that these children are wearing for their picture is typical of the 1920s.

This photograph shows a young man in the garb of the day. He seems to be thinking, "How soon can I get back in my overalls?"

Pictured here are two brothers dressed in clothing of the 1860s.

As this photograph reminds us, every boy has a friend if he has a dog.

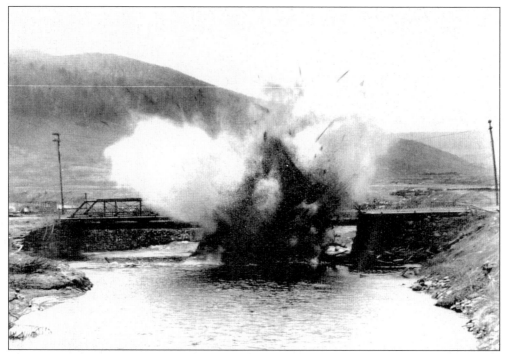

This striking photograph shows the Enfield dam being blown out as part of the total clearing of the territory.

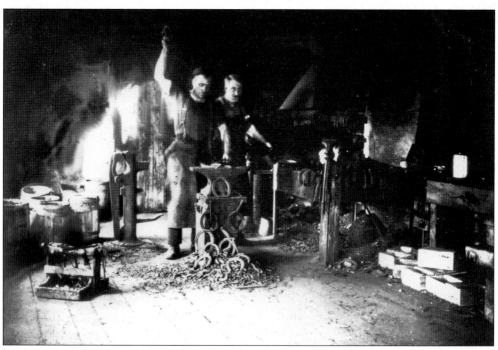

The Coolbeth blacksmith shop, shown in this photograph, served the needs of farmers in the town.

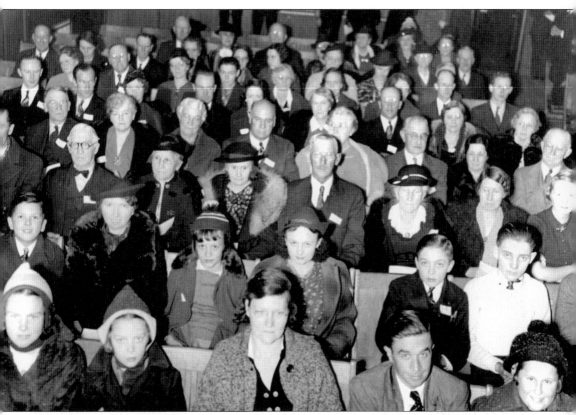

Known as the Farewell Ball, a final gathering of valley residents and friends was held on April 27, 1938, in the Enfield Town Hall. A huge crowd came from miles around to assemble one last time. When the clock tolled midnight, the orchestra played "Auld Lang Syne" and an indescribable wave of sadness engulfed the whole valley. Men, women, and children shed tears—grief with no place to hide. The photographs taken at the gathering show the range of emotions and the crowd trying to make the best of it.

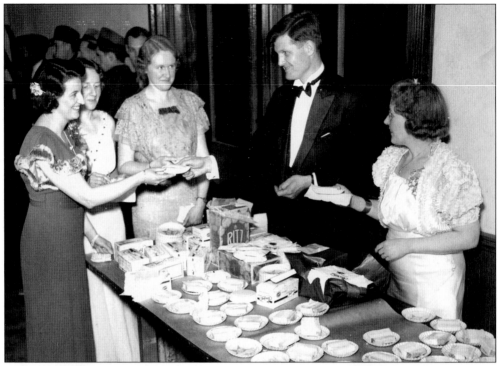

Light refreshment, ice cream, and crackers were served the night of the Farewell Ball.

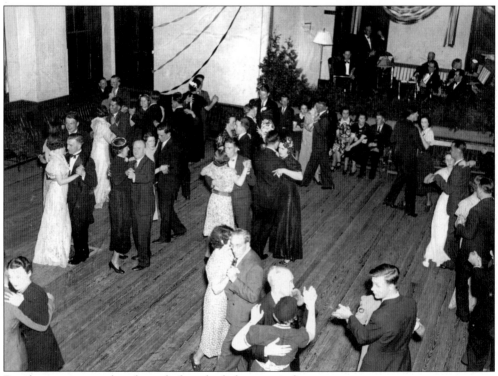

Residents enjoy one last dance before the lights go out forever.

Three
GREENWICH REVISITED

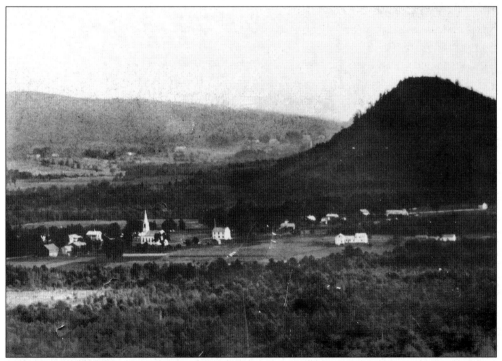

The little town of Greenwich (pronounced "green-witch"), tucked between Mount Pomeroy and Mount Liz, was incorporated in 1754. The original settlers were given land grants in return for military service, and Greenwich remained largely agricultural. Many Native American relics were found on the level plains that were presumably their summer campgrounds. Ironically, Greenwich was originally known as "Quabbin" or "Quaben"—the Native American word meaning "many waters." Greenwich is now beneath the deepest waters of the Quabbin Reservoir.

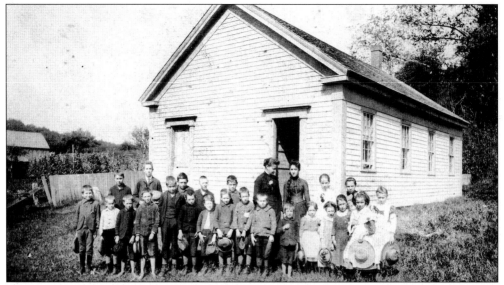

Shown in this *c.* 1888 photograph is the Greenwich Village School (No. 2). Fannie Walker was the teacher. The school burned *c.* 1898.

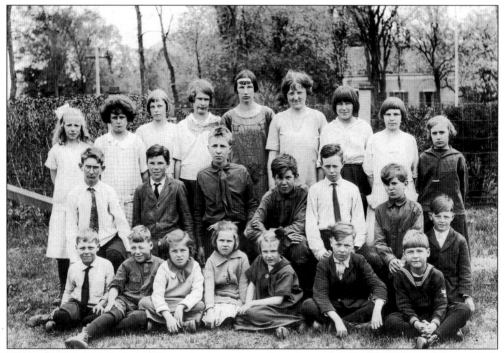

This photograph of a school's grades one through eight is dated 1924. The teacher, Edith Martin, is sixth from the left. A notation in her handwriting on the back reads, "My first class when I was 20 years old."

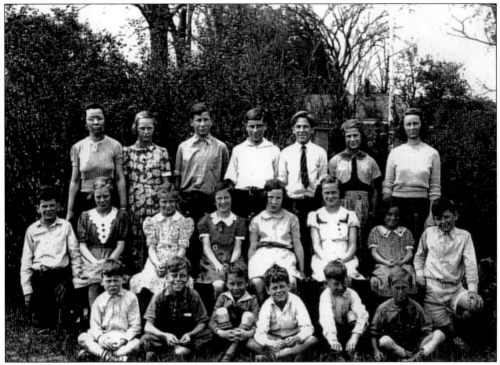

The last school in Greenwich closed in June 1938. The last three eighth-grade graduates, all boys, were Clifton Peirce, Reginald Prentice, and Charles Thresher.

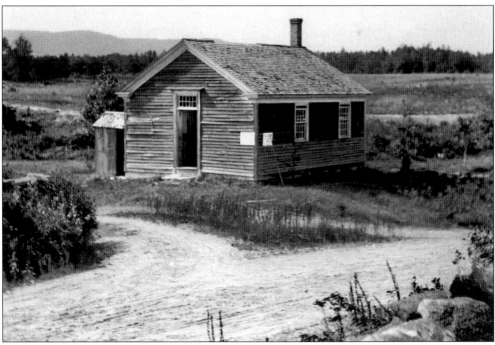

Shown in 1909, schoolhouse No. 3 in Greenwich was typical of neighborhood schools throughout the valley, with children of all ages learning together.

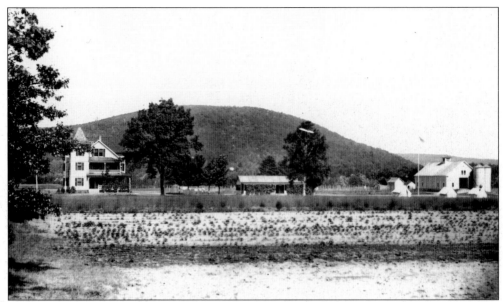

Hillside School, a residential school, was started by teacher-trained sisters, Charlotte Drinkwater and Mary Warren. The school was incorporated in 1901, and in 1927, the school was rebuilt in Marlborough, Massachusetts.

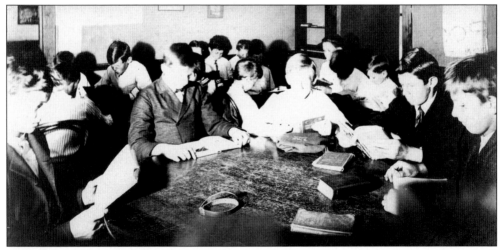

Orphaned and homeless boys from ages 5 to 16 were given formal education at the school. Here, they are deeply involved in learning and, after 100 years, the school remains an educational leader with emphasis on special learning needs.

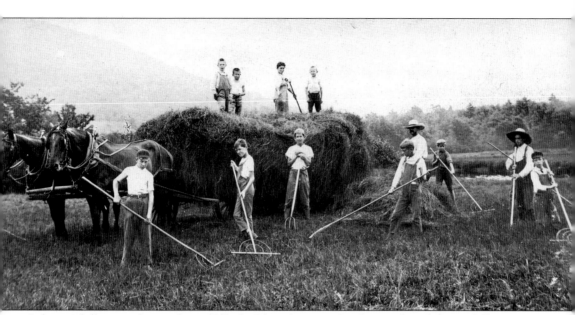

Lifetime skills were also taught at Hillside. These boys are developing their farming skills.

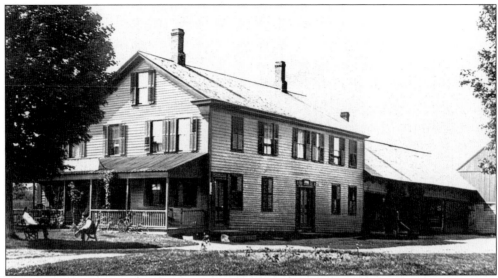

Shown in this photograph is the Hotel Greenwich in Greenwich Plains.

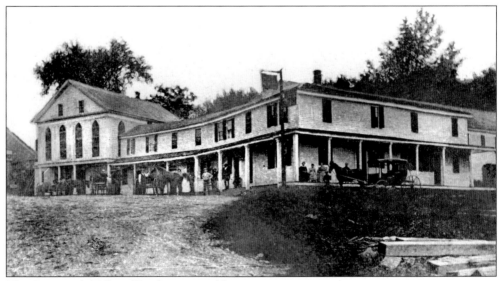

The Greenwich Village Hotel is pictured here.

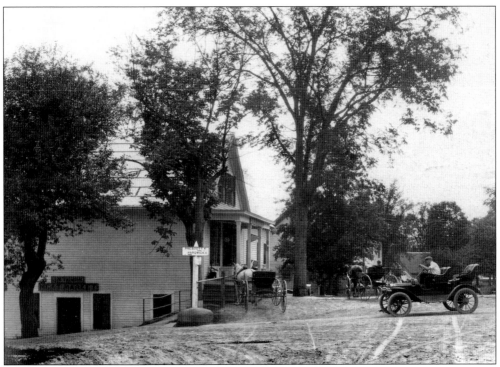

As shown here, going to market was by either horse and buggy or by automobile.

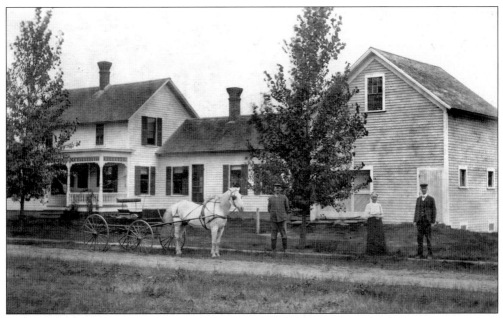

The fine-looking homestead shown in this photograph belonged to Charles Coit.

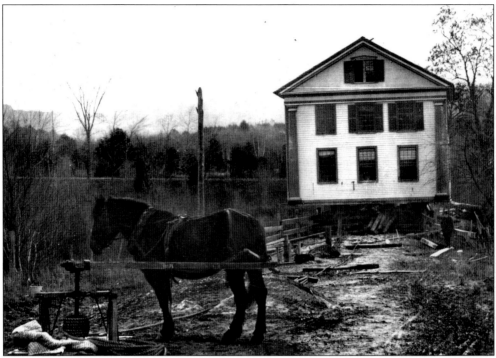

When the valley was cleared, most buildings were razed or burned. The Walker home, shown being moved intact with a horse-powered windlass, was among the few that were spared and relocated.

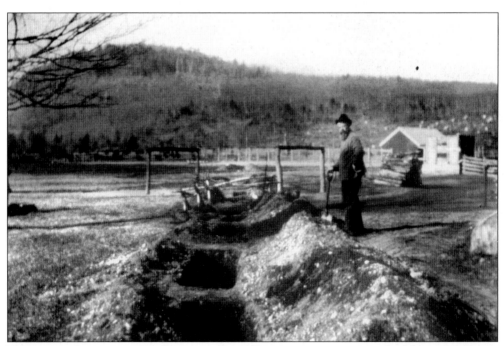

This man is digging a trench for a pipe that will carry water via gravity feed from a mountain stream in Greenwich to his home in the village.

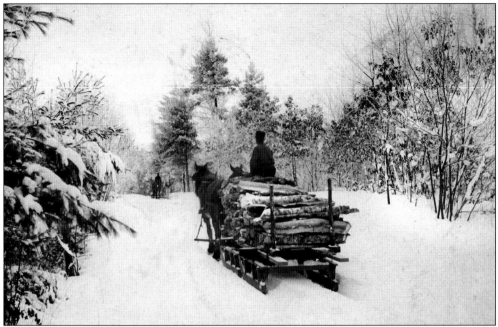

Gathering wood was a never-ending chore, as next year's woodpile must be collected and dried. Since it was the main source of fuel for heating and cooking, the average home consumed 10 to 14 cords annually.

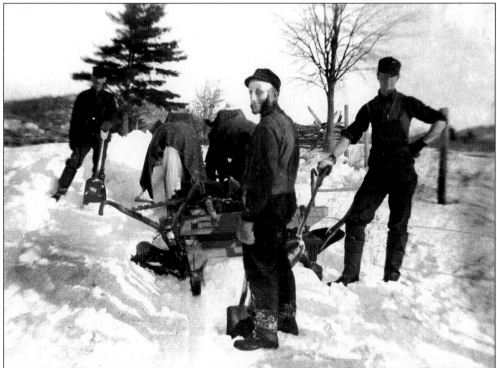

These men are breaking out the roads, or "pathing" the snow, which meant packing down the snow and doing whatever was necessary to make passage possible.

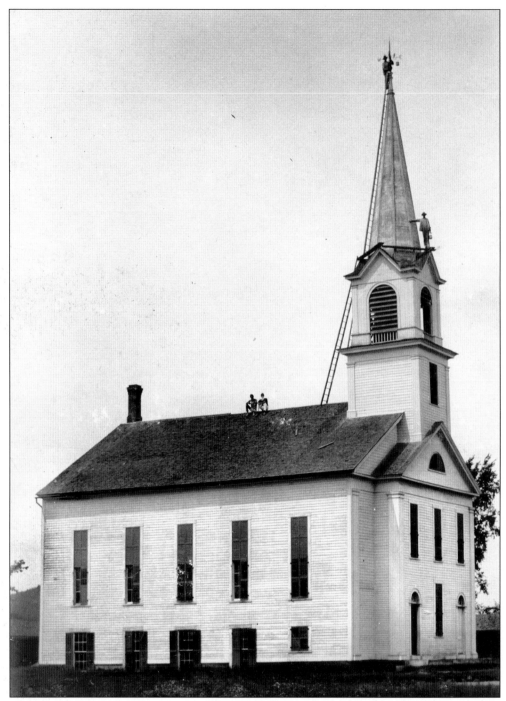

This picture of the Congregational church was taken by photographer Burt Brooks. The church is being painted. If you look carefully, you can see a man identified as Fred Moore at the top of the steeple.

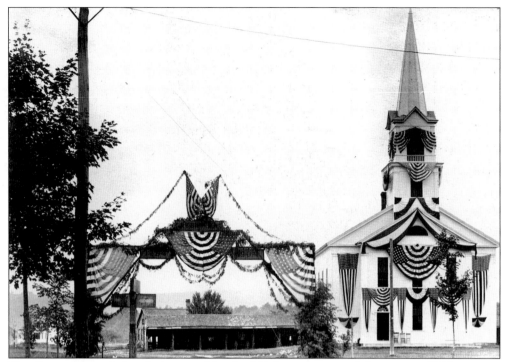

The Congregational church decorated for the 150th anniversary of the town in 1904.

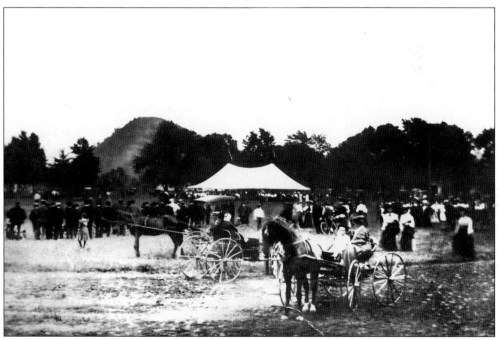

In 1904, Greenwich celebrated its 150th anniversary in a big way. Mount Pomeroy is shown here in the background. Today, only the tip of Mount Pomeroy is visible above the Quabbin's waters.

This is the special police force participating in maintaining law and order during the 150th-anniversary celebration.

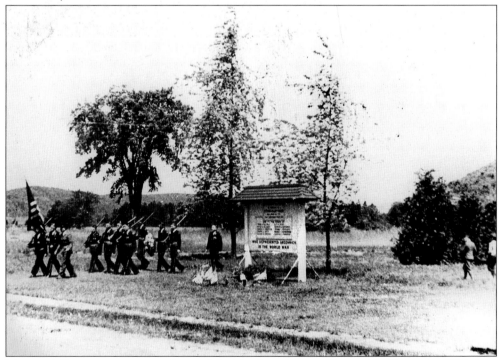

Memorial Day exercises were observed for the last time at Greenwich Plains in 1938. The honor roll seen here now stands at the Swift River Valley Historical Society in North New Salem.

The military achievements of Greenwich were numerous, and the inhabitants were known for their patriotism and generous support during the Revolutionary War, Shays' Rebellion, the War of 1812, the Civil War, and World War I. Sadly, the identity of these young Greenwich soldiers is unknown.

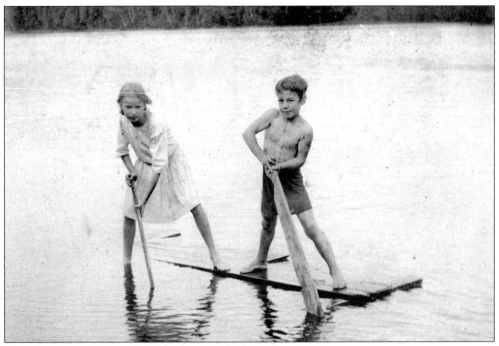

Two children enjoy a summer day of rafting on Warner Pond.

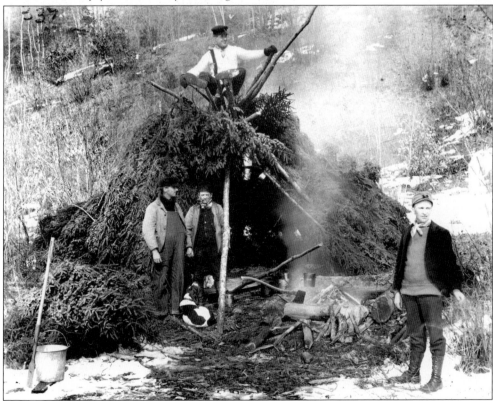

Fun was not just for children. These men are camping at Davis Pond.

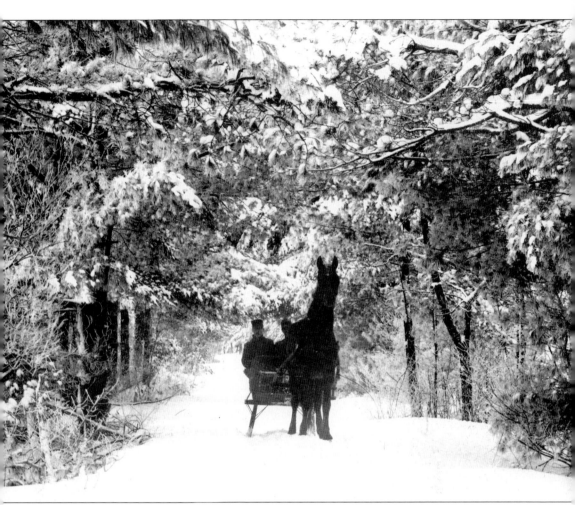

This picture could be titled "Stopping by the Woods on a Snowy Evening." The horse shown is named My Boy Billy. Like countless others, he made travel on snowy roads possible by sleigh. Sleighing was also great sport, with many organized sleigh rides ending at the church or Grange Hall, where a chicken pie or oyster supper might be served, followed by an evening of dancing.

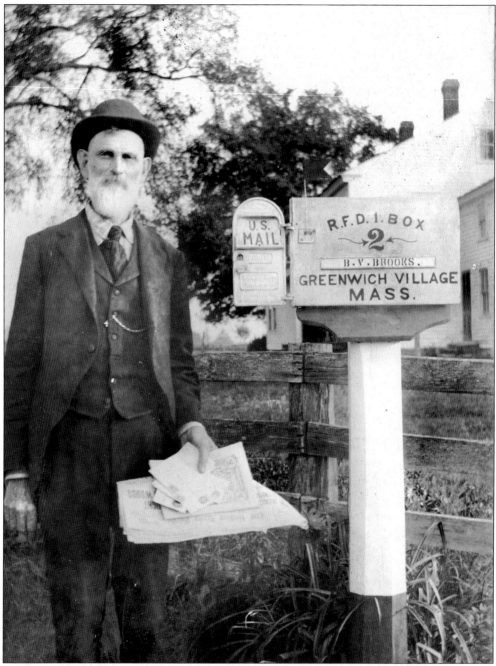

Burt Vernon Brooks (1849–1934) has provided a rare window on life and times in Greenwich by his photographs and paintings. Many examples of his work can be seen at the Swift River Valley Historical Society.

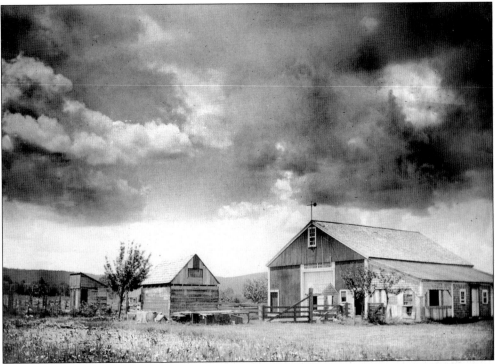

This photograph of Burt Brooks's home and outbuildings shows smoke overhead from a huge forest fire on Mount Pomeroy. It was estimated that 700 acres of forest burned in April 1911.

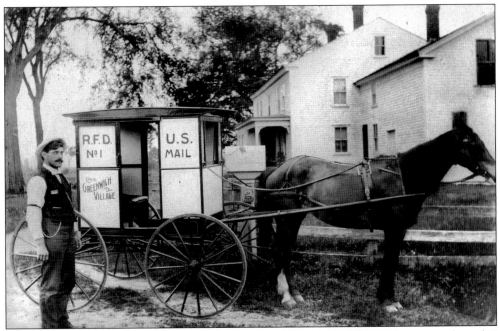

Harrison Thresher of Greenwich was the epitome of the saying "The mail must go through." He delivered the mail in all kinds of weather for 32 years and never missed a day.

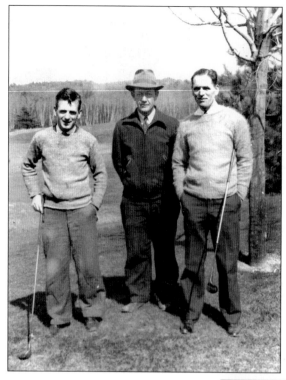

The Dugmar Golf Course was built by two executives of the Chapman-Davis Manufacturing Company of Springfield, Massachusetts, and was a playground for them. The golfers in this photograph appear to be resting. Remnants of the clubhouse are visible above the waterline today.

Here, the Stuart family, who lived near photographer Burt Brooks, poses for a family picture.

Dr. Mary Walker (1832–1919) had summer property and relatives in Greenwich. She was an extremely independent and competent woman with many firsts to her credit. She served on the battlefields of the Civil War as a contract assistant army surgeon and spent four months as a prisoner of war in a Confederate prison. Pres. Andrew Johnson awarded her the Congressional Medal of Honor in November 1865. She was an ardent supporter of women's suffrage and should be remembered for her many contributions rather than for her insistence on wearing men's clothing and short hair.

Maude May Billings is pictured here showing the demeanor of all young ladies of the time.

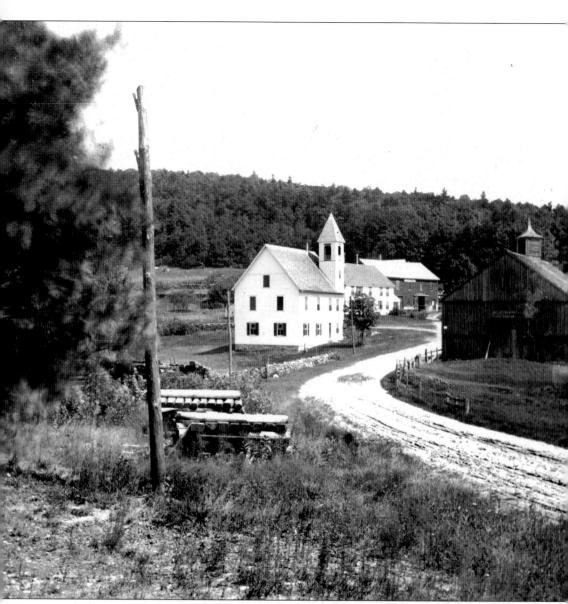

In 1885, following serious religious turmoil in Greenwich, Henry Warner Smith founded and built a spiritualist church, known as the Independent Liberal Church, which was dedicated in 1885. Between 1901 and 1902, after serious controversy in the town and within the congregation itself, Smith tore down the church he had so proudly built. He used the salvaged material from it to construct a chapel as an addition to his home and called it "the Spruces."

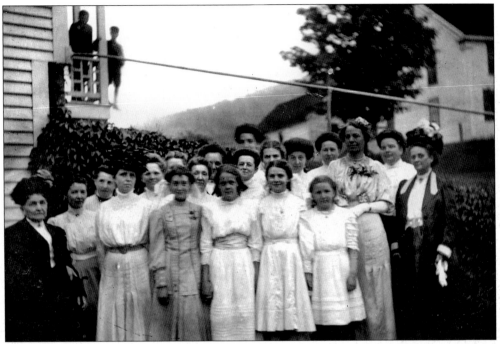

Posing here are members of the Ladies Society of the Independent Liberal Church.

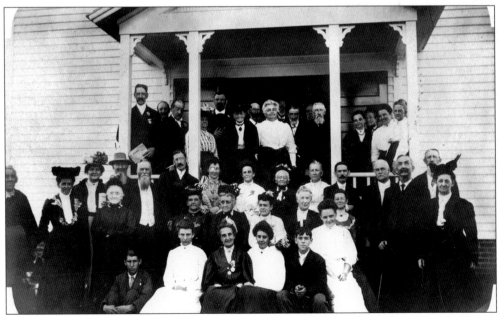

This is a more formal gathering of the congregation of the Independent Liberal Church in Greenwich.

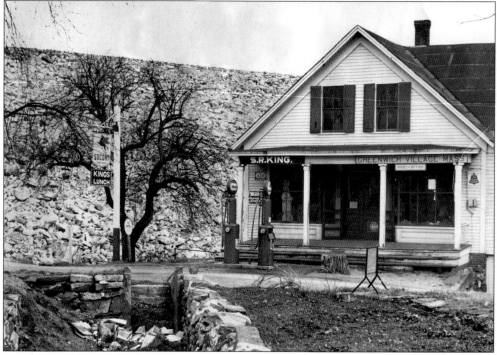

The village store and post office in Greenwich was last run by S.R. King. Specials were advertised on the small sandwich board seen in front of the store. The huge rock pile to the left is the baffle dam under construction.

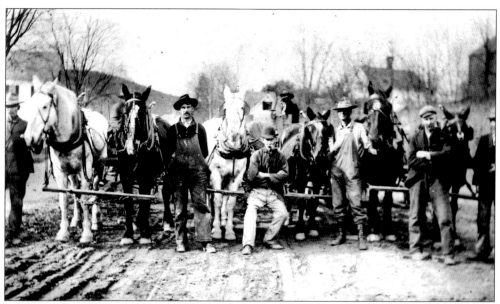

The Greenwich road crew includes, from left to right, ? Nevins, John James, Albert Stevens, Webster Parker, M. Schemerhorn, and Ed Randall. Ed Randall, a highway surveyor and constable, suffered a fatal fall in 1934 while working with a town crew near the Dugmar Golf Course.

The tollbooth shown here is a forerunner of the many tollbooths found today along major highways. It was ordered by the legislature, and the proceeds were used to maintain the roads, with rates being set according to loads. A man with a horse was charged 5¢, and a four-wheeled wagon or carriage drawn by two horses was charged 25¢. Some passage was free, such as for military duty, traveling to and from church, or passage to a mill or job.

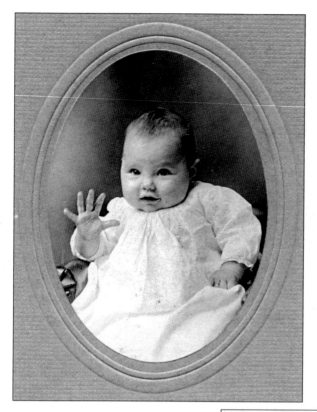

The darling unnamed baby shown in this photograph was too young to know what was happening to her home.

Selina Stetson Morse is shown in this photograph.

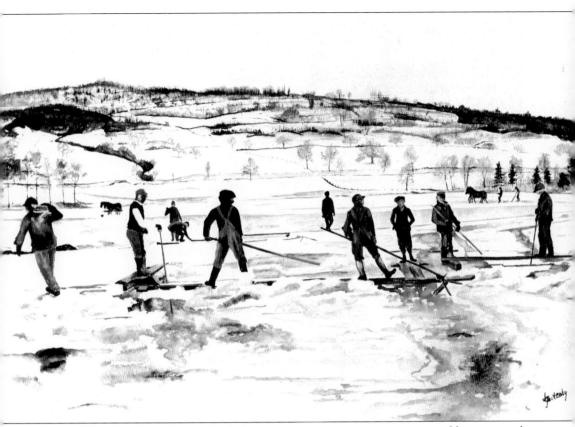

Although it was cold, treacherous work, harvesting ice was an important seasonal business, and Greenwich Lake yielded 20,000 tons of ice in a good year. Large cakes of ice were marked out with a special tool drawn by horses, and the ice was sawed by hand. It was then pushed around with a pike pole, gathered, and packed in straw or sawdust in an icehouse. The cakes would stay frozen for a long time, allowing it to be shipped by train, as needed, to the cities and towns in the East. (Painting by Jean Gaitenby.)

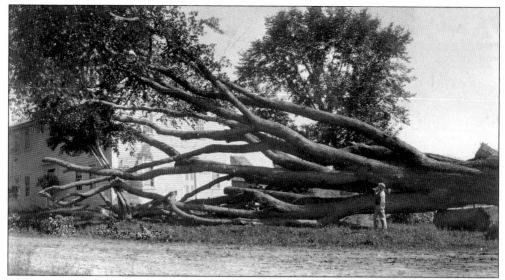

This American elm is estimated to have been between 160 and 180 years old. It was located on property of the Bruce family in Greenwich Plains. A wet spring or fall and a low spot in the terrain allowed the tree to be shallow-rooted, and so it was easily toppled. This information comes to us courtesy of Frank Tree Maintenance, Florence, Massachusetts.

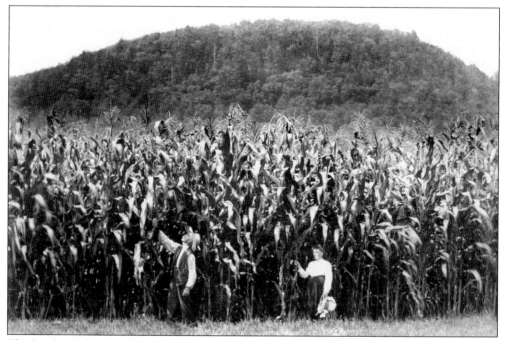

The height of the corn shown here is testament to the fertility of the valley's soil.

Four
PRESCOTT REVISITED

Prescott was the youngest of the four submerged towns and was the first to give up its identity in 1928. The town was named for Col. Warren Prescott, who was killed at the battle of Bunker Hill. Agriculture was the town's main occupation, and grains and fruit were the main crops. Prescott included gristmills, lumbermills, taverns, schools, churches, stores, and cemeteries and was the only town to be preserved in a written history, complete with a genealogy.

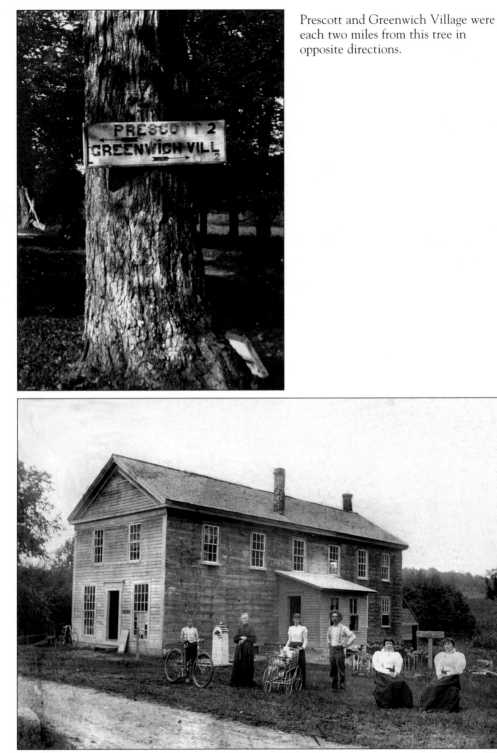

Prescott and Greenwich Village were each two miles from this tree in opposite directions.

This is the general store in Atkinson Hollow *c.* 1893, when it was run by Henry Shaw. The upper floor was the location of the Grange Hall.

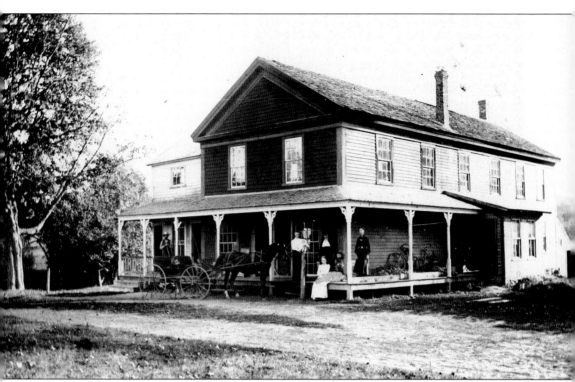

A large porch having been added, the store in Atkinson Hollow was last operated by Harrison Peirce. There was also a pool table and a checkerboard where shoppers could sharpen their skills. The Grange Hall upstairs was the gathering place for dances, suppers, quilting parties, taffy pulls, and much more. Iva McKenney of Orange, now in her 90s, lived across the road and, as a young girl, had the job of cleaning the hall each week—for 50¢.

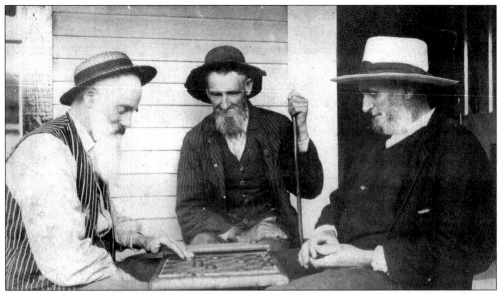

These gentlemen are engaged in a game of checkers at the store.

This photograph shows the aftermath of a severe ice storm that encapsulated the Atkinson Hollow section of Prescott.

Situated at the Four Corners of Prescott Hill and Enfield Road, the Felton Tavern was one of the early stopping places on the stage route. Prior to the town's elimination, the building was razed and rebuilt in Bethel, Connecticut.

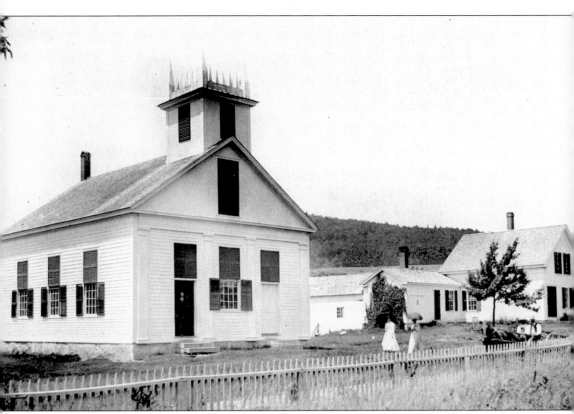

The Methodist Episcopal church and parsonage in North Prescott were built in 1837. When the boundaries for the Quabbin watershed were laid out, the church was 20 feet over the line and was, therefore, scheduled for demolition. A group of Prescott citizens was successful in a bid to purchase the building for the Prescott Historical Society. In 1949, the structure was moved to nearby Orange. In 1985, when the society merged with the Swift River Valley Historical Society, the structure was moved to their grounds. The former parsonage, now a private home, sits just outside the chain-link fence on a tiny remaining sliver of Prescott soil, now part of New Salem.

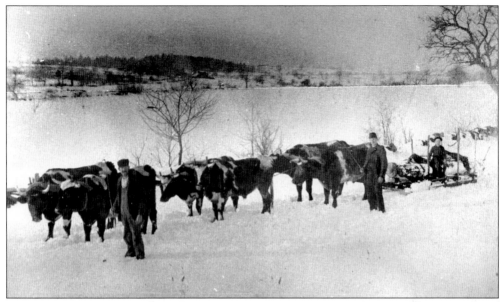

A forerunner of plowing, these teams of oxen are shown pathing the roads in January 1891. Shown with the teams are, from left to right, Walter L. Hunter, Edward M. Hunter, and John Metcalf (seated).

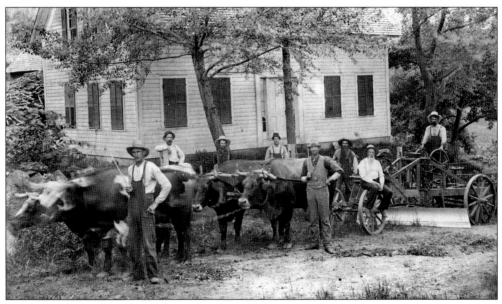

This road crew is scraping and smoothing the road after the winter snow.

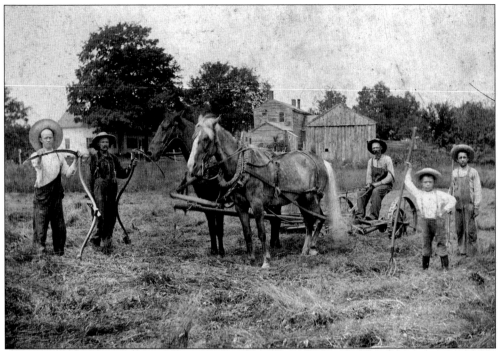

As the old saying goes, "Make hay while the sun shines." When that day came, young and old were busy in the fields.

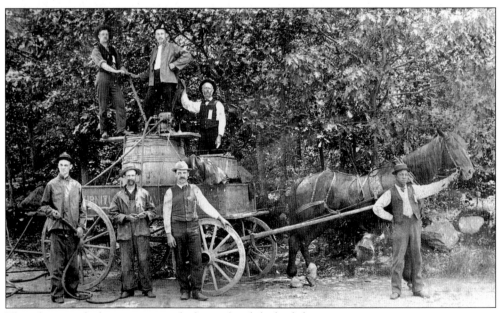

This photograph shows a very early form of mobile firefighting equipment.

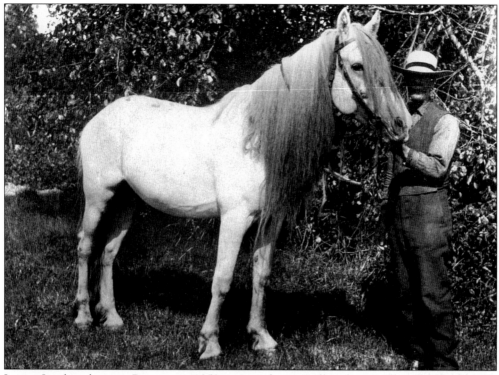

Lucius Lawless, born in Prescott in 1852, operated a sawmill and gristmill in the Cooleyville section of New Salem. In this photograph, Lawless is seen posing with his beloved horse.

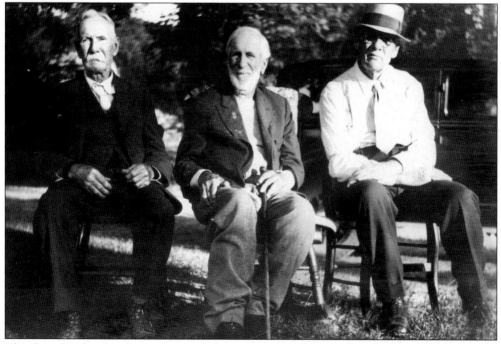

The three Lawless brothers are, from left to right, Merrill (age 91), Lucius (age 89), and John (age 77).

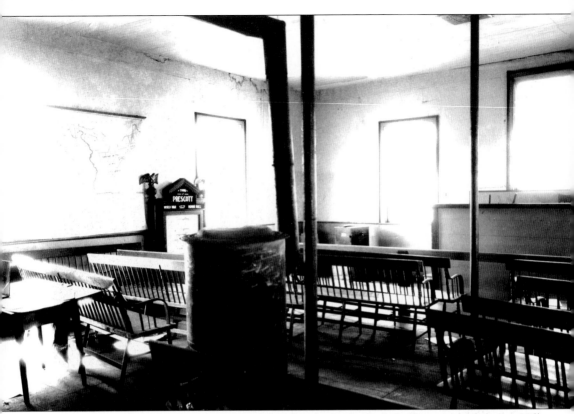

This is the interior of the Prescott Town Hall, which was built halfway up Lighthouse Hill, following lengthy and heated arguments as to just what was the center of town. The original Prescott Honor Roll is shown in the picture, and although there are several stories as to its whereabouts today, the person who knows is not telling. A reproduction stands on the grounds of the Swift River Valley Historical Society with the originals from Dana, Enfield, and Greenwich.

The identity of this man is not known, but the glass-plate negative from which this picture was made came from Daniel T. Pierce, a photographer born in Prescott in 1850.

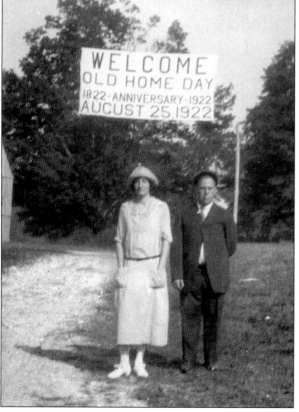

Prescott celebrated its 100th anniversary on August 25, 1922. The welcome sign was crafted on a bedsheet by Mabel Peirce, shown here with her husband, Harrison.

91

Fred Peirce served for 40 consecutive years as the town clerk of Prescott.

Silas Whitaker and his wife, Celia, pose with their children Lilla, Earl, and Leola. In later years, Earl became the local mail carrier.

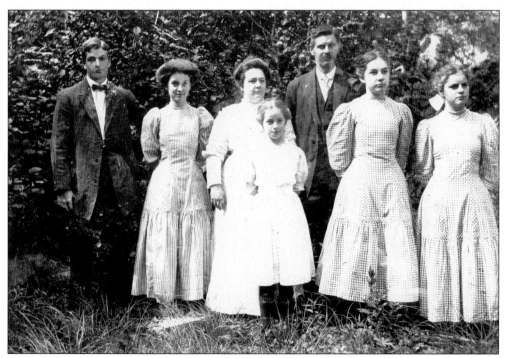

Frank Currier and family are, from left to right, John M., Celia E., mother Ella, Fannie Emma, father Frank, Bessie E., and Rosa M.

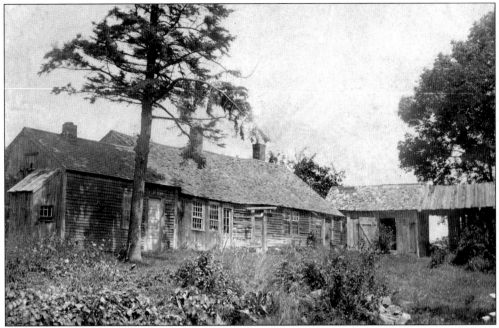

The Hemenway home, built probably *c.* 1800, was located on Fish Hill in Prescott and was one of the earliest homes in the area.

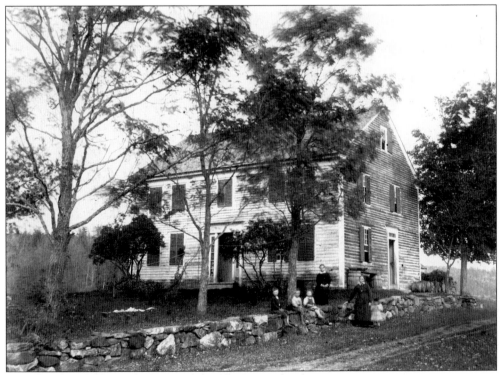

This photograph shows the home of the Ellis Pierce family.

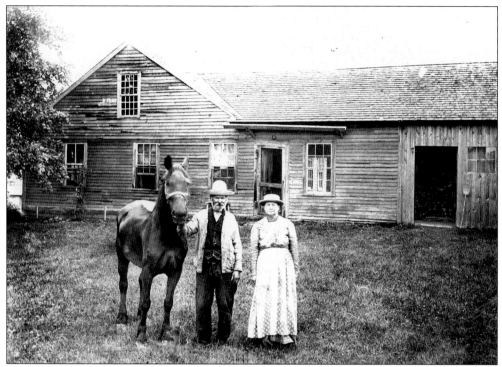

Mason Haskins and his wife pose in front of their home, built in 1804.

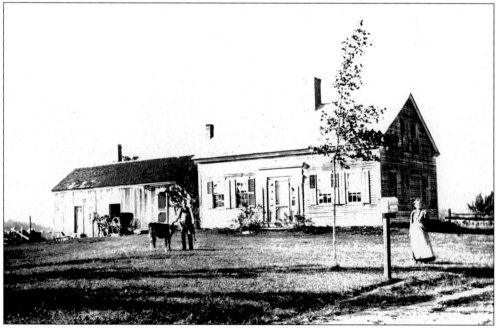

This photograph shows an early Prescott home complete with the animals.

Showing the typical "house at the end of the road," this photograph won a second prize of $5 in a country road contest sponsored by the *Chicago Record-Herald* in 1902.

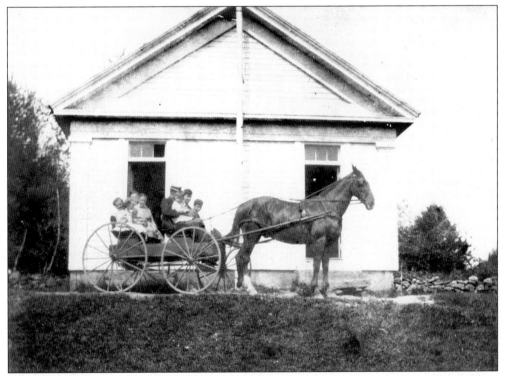

This photograph shows the school wagon arriving at the No. 4 school with a load of children in the days before yellow school buses in the valley.

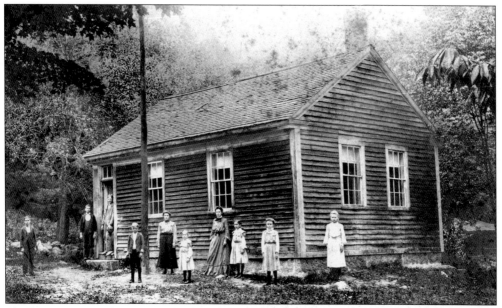

Shown in 1924 at the No. 5 school in Prescott are, from left to right, Earl Whitaker, Merle Brown, Oscar Stacy, Conrad Lincoln, Celia Whitaker, Vera Brown, teacher Alice Lucus, Gladys Brown, Leola Whitaker, and Bernice Stacy.

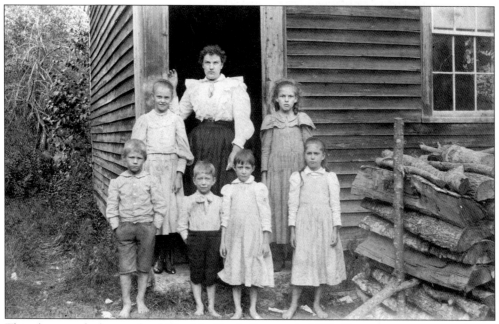

This photograph shows school No. 1 in North Prescott in 1895. Shoes were not required.

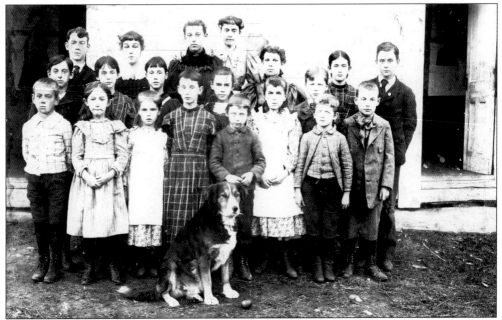

This photograph shows the entire student body of the No. 3 school on Prescott Hill in 1906. Pets were welcome.

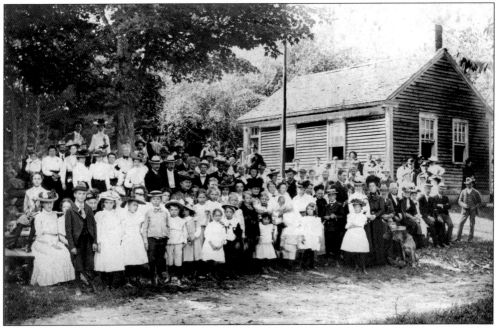

Old Home Day was the biggest celebration of the year. In this view, residents gather at the Under Hill School for a day of sociability, food, and fun. Although it was officially the No. 5 school, it was called Under Hill because it was at the bottom of the hill.

These Prescott ladies are unidentified, but they appear to represent five generations. The image was reproduced from a tintype in the society's collection.

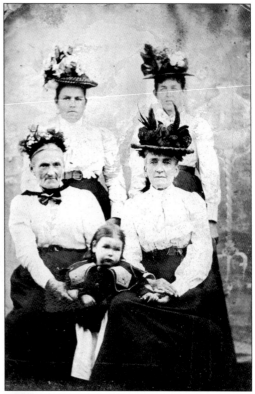

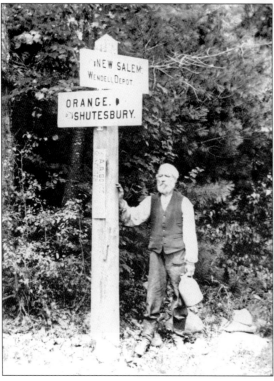

Pratt Furbush rests while deciding which way to go. Does he have water, molasses, or something else in the jug?

These Prescott children are, from left to right, Frances Pettingill, Oren Jones, and sister Iva Jones.

Dated May 5, 1872, this picture shows the handsome four-and-a-half-year-old Atwood Collins Page in his first pair of trousers.

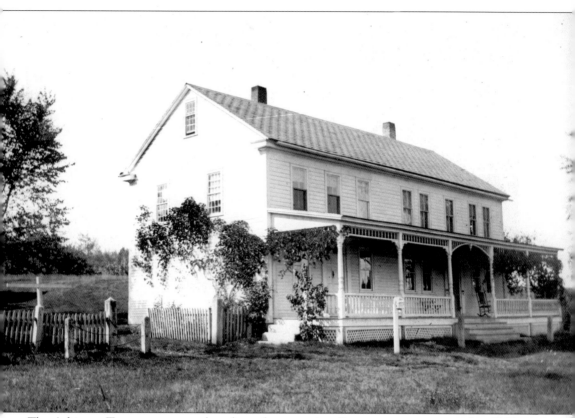

The Atkinson Tavern was opened at about the same time Prescott was incorporated in 1822. It was run by John Atkinson, a Revolutionary War veteran who served under Gen. George Washington. This building was razed and rebuilt as the Storrowton Tavern on the Eastern States Exposition grounds in West Springfield, Massachusetts. John Atkinson had great respect and admiration for General Washington, and in 1850, he erected a monument in his honor. The inscription reads, "In grateful memory of the American forces whose valiant service made this land of ours free and possible." The monument stands today in Quabbin Park Cemetery.

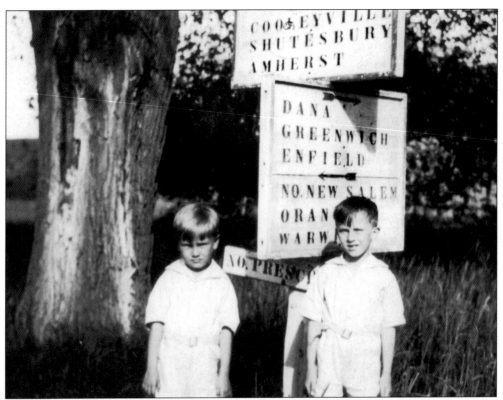

Jack (left) and Harry Coyle pose in front of the road sign that tells it all.

These little girls, Mary Alida (left) and Abbie Haskins, seem to be taking life very seriously.

Lillie Pierce Coolidge is the author of *The History of Prescott*, complete with a section on the genealogy of Prescott families. Prescott is the only one of the submerged towns that has a published history. Coolidge was also the driving force behind the establishment of the historical building and society for Prescott.

In Memory of

ELEANOR GRISWOLD SCHMIDT

1913–1994

Whose love of the valley and vision for the future make this museum possible.

"Now I have two beauties; one to remember and one to enjoy."

Eleanor Griswold Schmidt of Prescott was a tireless worker for the Swift River Valley Historical Society. She loved the valley and cherished her memories of it. She was the force behind the merging of the Prescott Historical Society with Dana, Enfield, and Greenwich. Eleanor Schmidt was a compelling fund-raiser and was extremely generous with her time and money. Her wish was that the story of the valley would continue to be told, and she established a trust fund to make it possible.

Five

NEW SALEM REVISITED

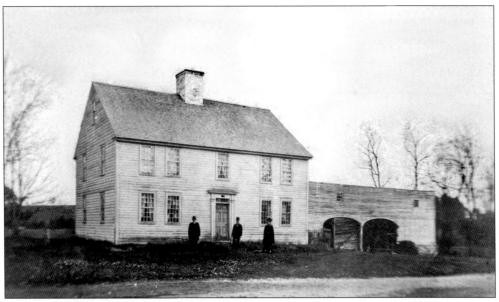

New Salem was the lucky one, surviving with only a few villages swallowed up by the Quabbin Reservoir. New Salem was incorporated in 1754 and was so named because many of the early settlers migrated from Salem, Massachusetts. The historic common high on the hill is dotted with old homes, remaining buildings of the New Salem Academy, the Unitarian church (built in 1794), and the Congregational church. The town of fewer than 1,000 inhabitants is mainly residential and has a general store, post office, and regional elementary school. Rich in history, New Salem celebrated its 250th anniversary in 2003. The Hascall-Haskell home, pictured here, is the oldest in the North New Salem village and looks much the same as when it was built more than 200 years ago.

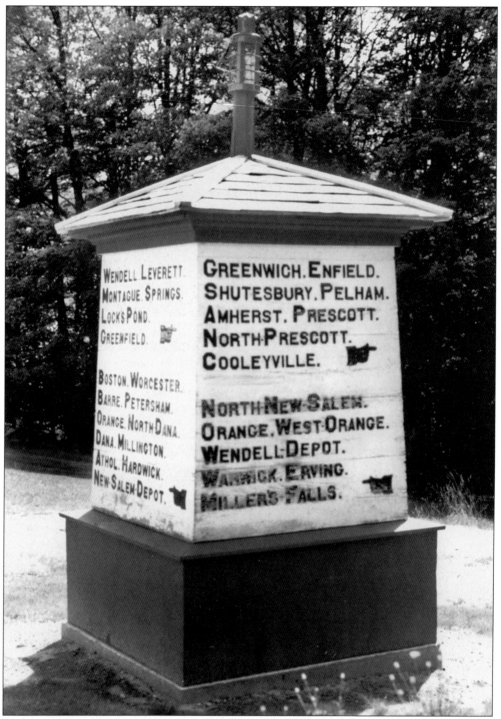

This signpost was originally placed at a five-corner intersection near the center of New Salem. With the closing of access into the valley, it had outlived its purpose and now stands in the yard of the Swift River Valley Historical Society.

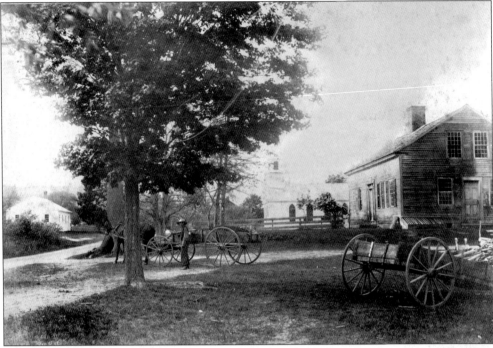

This early picture of the village of North New Salem shows the schoolhouse on the left, the Congregational church opposite, and the original home of Dr. Andrews in the forefront.

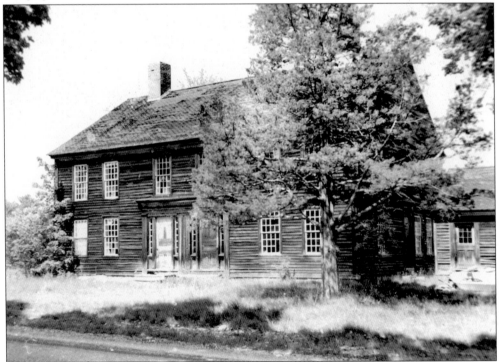

This photograph shows a tenderly maintained old home on Elm Street, a short distance from the Swift River Valley Historical Society.

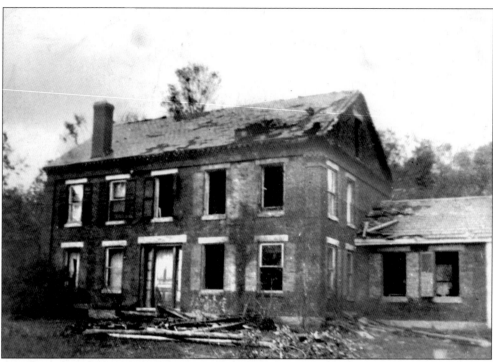

Built from bricks that were undoubtedly from the nearby brickyard operated by Cyrus Crowl, this house suffered severe damage in the 1938 hurricane, as seen in this picture.

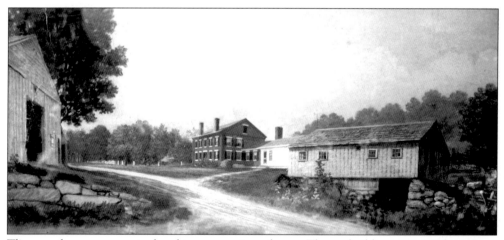

The same home was repaired and is now a private home. The outbuildings seen in the picture are now gone.

Many homes had three generations living under one roof—this grandmother is busy crocheting a doily.

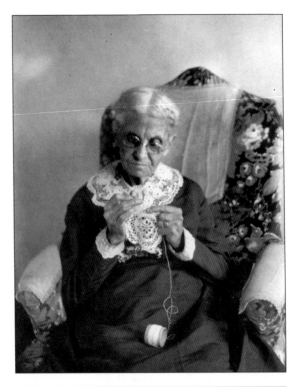

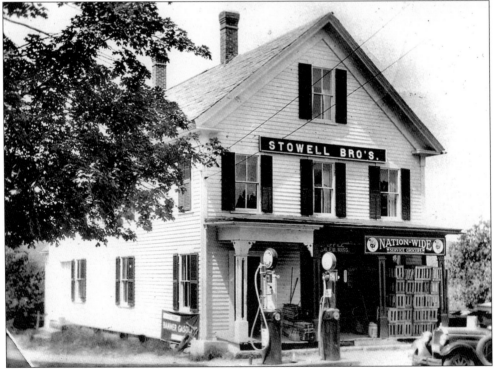

The Stowell brothers ran this general store until 1930, when they built a new one on the highway near the center of the town.

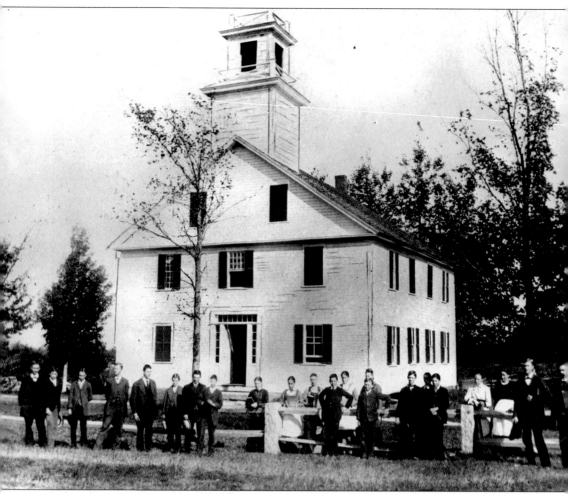

New Salem Academy opened in 1795 in response to a need for higher education. The school survived until 1957, when a regional high school was built in nearby Orange, Massachusetts. When the academy first opened, the school year was six months long and the teachers were paid 44¢ per day. Subjects taught were English, French, Latin, Greek, Chinese, needlework, drawing, piano, penmanship, and much more. It began as a private boarding school and ended its existence as a public vocational high school.

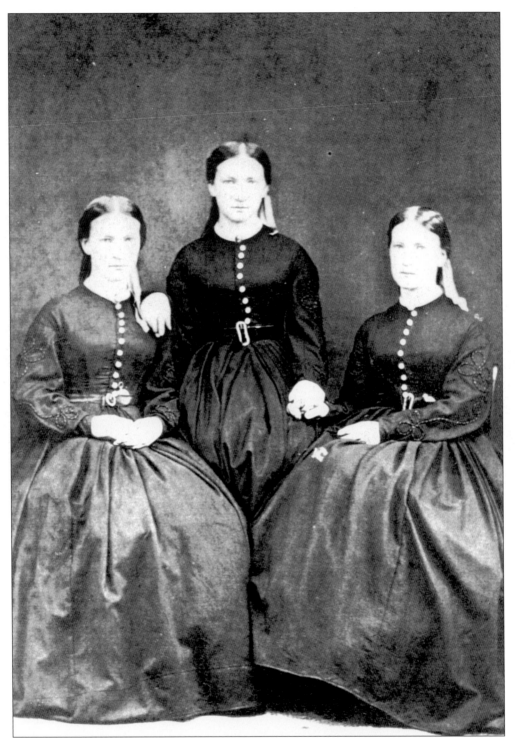

From left to right are Mary, Mahala, and Maria Goodnow. They were born in New Salem in 1845. The cradle in which the girls slept as babies was custom made by their father and is on display at the Swift River Valley Historical Society.

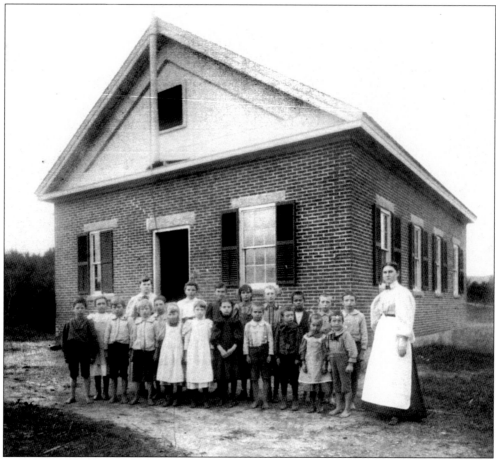

This photograph shows a group of schoolchildren at the Millington Grammar School in 1895.

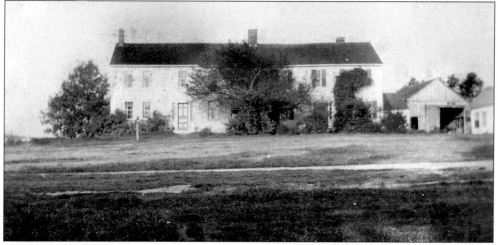

Located on the stage route from Cooleyville, the Stratton House was one of the earliest homes in New Salem. The house was expanded several times until it became 72 feet long. It burned in 1921.

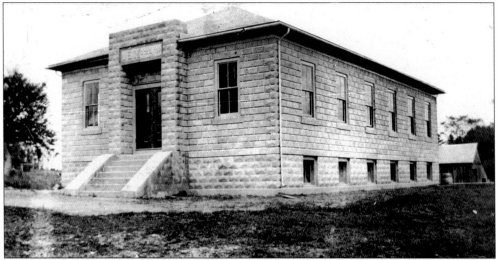

Moore Hall, located in Millington, was built for the community by William Moore, a successful businessman. It was used for all kinds of activities. At the closing of the valley, it was removed and rebuilt for the Ware Rod and Gun Club.

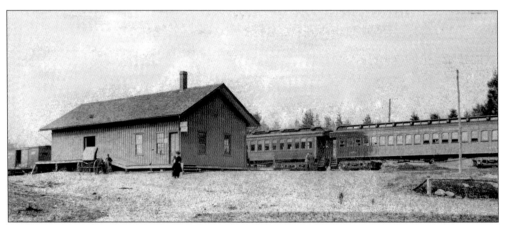

With the former railroad bed serving as a favorite hiking trail along the shoreline, the site of the New Salem railroad station is barely visible today on the shores of the Quabbin Reservoir.

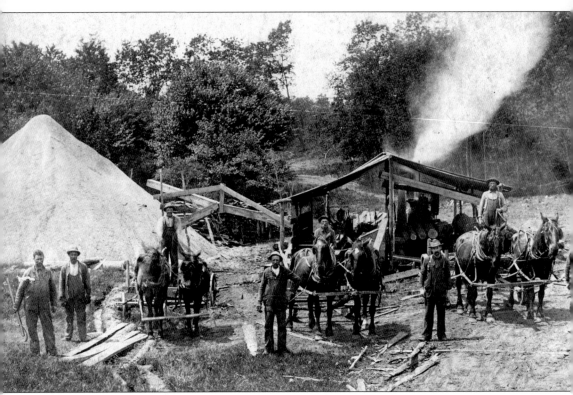

Photographs of sawmills were very popular in the late 1800s, and many collections are in existence, including the Paige sawmill (shown here). The pile of sawdust seen to the left of the mill had many uses, including bedding for animals, banking for houses to protect from winter cold, and as packing for ice cakes in the icehouses.

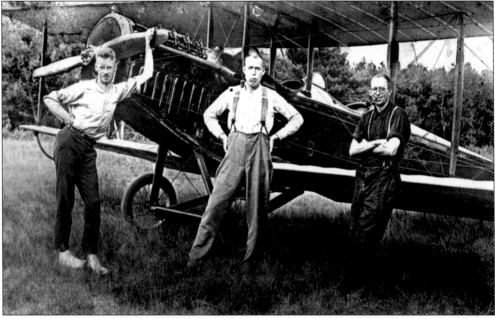

Levi Flagg (center) had ideas that were way beyond his time. One such idea was the Climax automobile, run by electric power. Flying machines were also one of his interests.

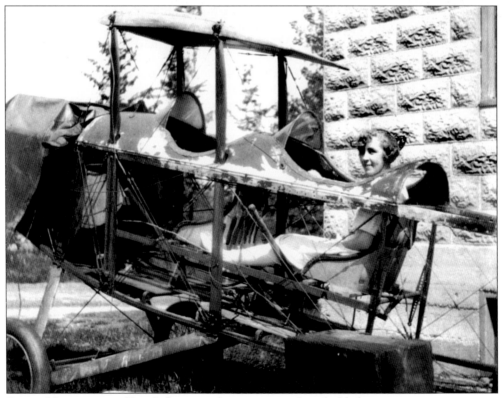

Pictured here in one of Levi's flying machines is an unidentified lady passenger.

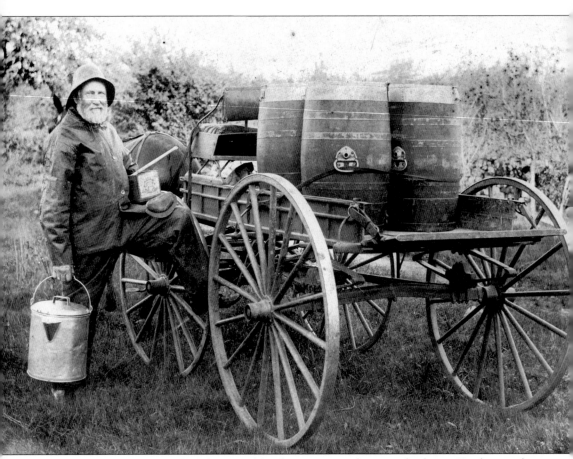

Here, Levi Newton is making his rounds gathering cream from nearby farms. He then took it to the Millington Creamery, where it was made into butter and sold in the local stores. There was also a cheese factory in Millington, which was a small village in New Salem that is now under water.

This photograph shows the original meaning of "horse power." Before tractors, horses provided the means to plow, cut hay, and haul produce.

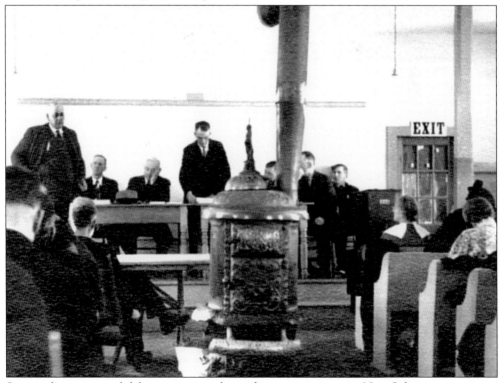

Serious discussion and debate were in order at this town meeting in New Salem.

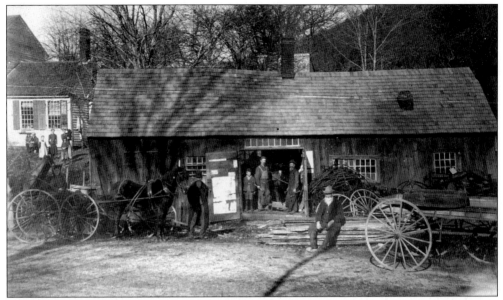

The Powers Blacksmith Shop was a good place to hear all the latest news while waiting to have a horse shod or a wheel repaired. Here, Mae Horr is seated in the wagon. Her father, Herbert, stands beside the horse. Shop owners Elmer and Orison Powers stand in the doorway, and Appleton Gray sits on the lumber pile.

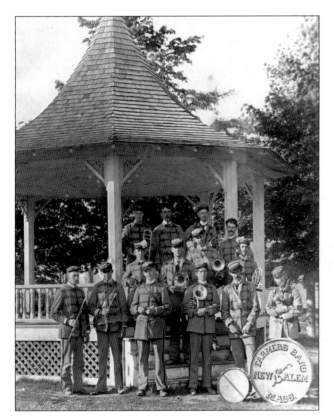

The Farmers Band of New Salem is shown here after performing at the wedding of one of its members. The drum is on display at the Swift River Valley Historical Society.

The three Paige sisters, daughters of Alba and Althea Paige, made history as they were wed in a triple ceremony in February 1906. Here, they are in their going-away costumes. All three honeymooned in the city of Boston.

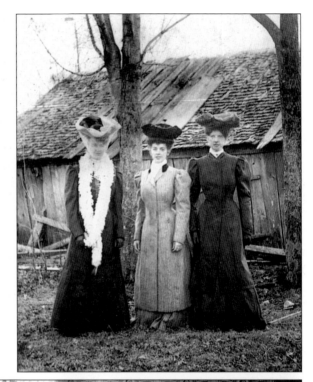

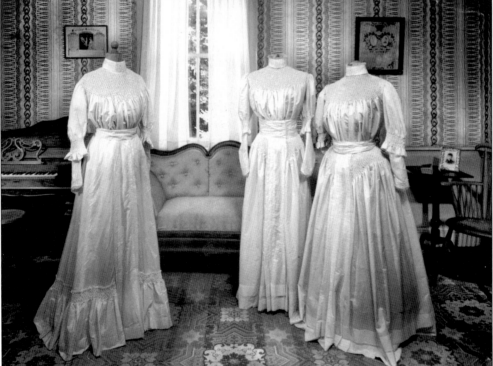

The wedding gowns of the Paige sisters are on display at the Swift River Valley Historical Society. (Courtesy Peter Peirce.)

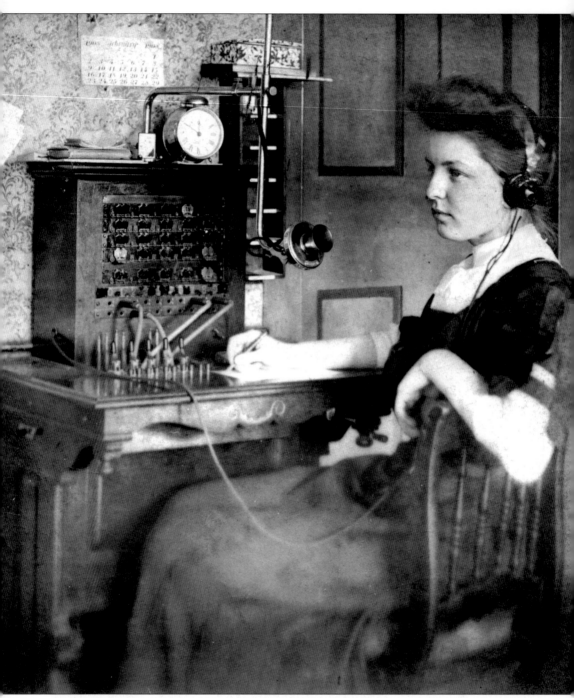

Here is the telephone operator at the switchboard of the Highland Telephone Company in 1908. The company was started by Rawson King and Willard Putnam with 14 subscribers, and the lines between Millington and New Salem were all on one circuit. Prior to this, in 1887, King installed a vibrating telephone between his house and the Putnam House. To make a signal, one had to use a small wooden hammer to tap the instrument.

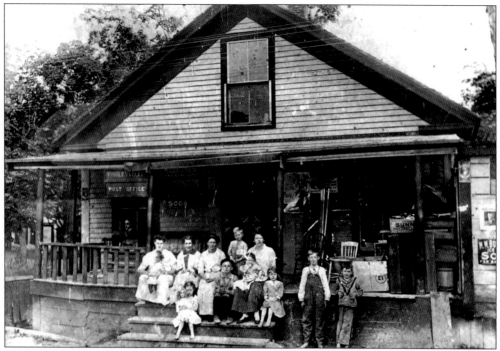

The general store and post office in the Cooleyville section of New Salem was a favorite gathering place for villagers. Cooleyville got its name from Merrick Cooley, the village blacksmith.

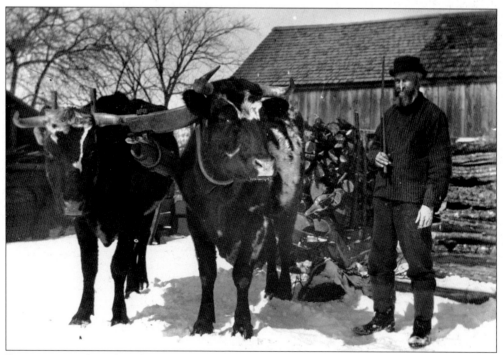

Rawson King of Cooleyville is shown in this photograph with a load of firewood drawn by his team of oxen.

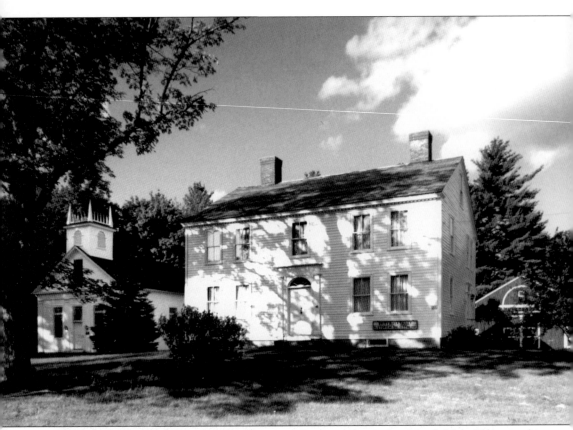

The home of the Swift River Valley Historical Society is located in North New Salem in this large house that was built for Judge William Whitaker in 1816. The house holds artifacts from Enfield, Dana, Greenwich, and New Salem and has many interesting features, including some original wallpaper and a stenciled stairway. Adjacent is the Prescott Church Museum, originally built as a Methodist Episcopal church in 1837. It was moved to this site in 1985, when the Prescott Historical Society merged with the Swift River Valley Historical Society. Although the church building is modern in convenience, the 1837 appearance has been retained. The third building, filled with exhibits, is the Peirce Memorial Carriage Shed, built in 1991. A replica of an early schoolroom is built within this building, and an authentic outhouse stands just outside. The large barn (c. 1850) is maintained for looks but contains no exhibits. The museum is open to the public from June to October. (Courtesy of Peter Peirce.)

POSTSCRIPT

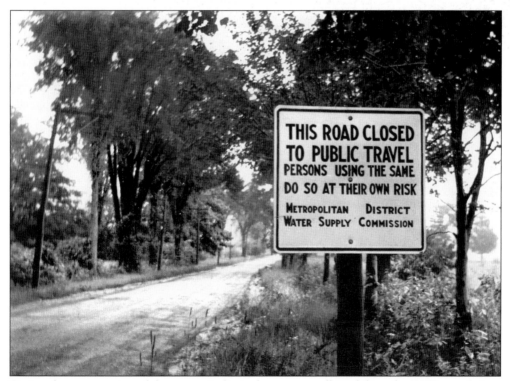

During the construction of the reservoir, limited access was allowed, but after 1938, restrictions were in place. Today, access to the reservoir and its watershed is limited or allowed by permit only.

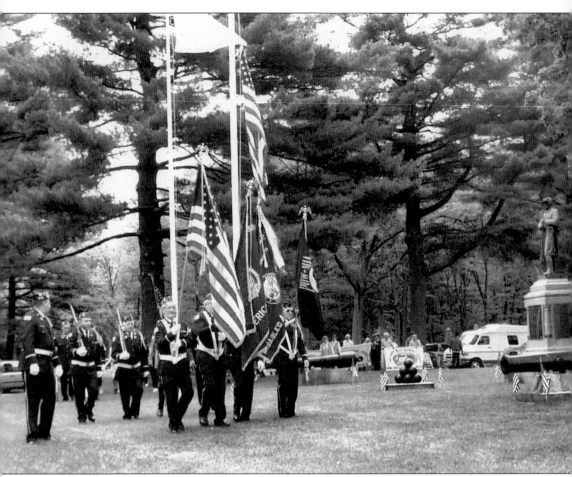

This photograph shows members of the American Legion Post No. 239. The Quabbin Park Cemetery is the site of a Memorial Day observance that is sponsored each year by the Metropolitan District Commission.

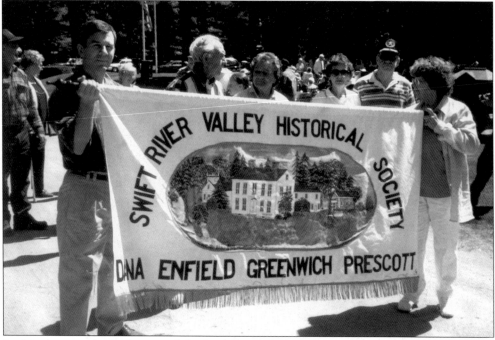

In this photograph, the banner of the Swift River Valley Historical Society is paraded.

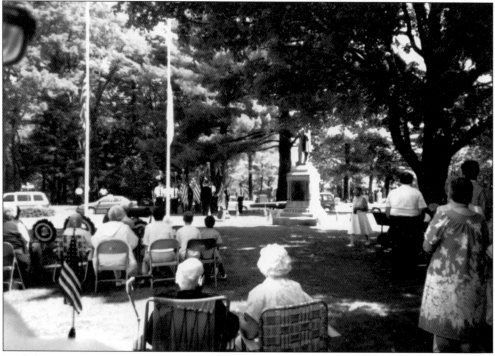

With hundreds in attendance, a concert follows the program—weather permitting.

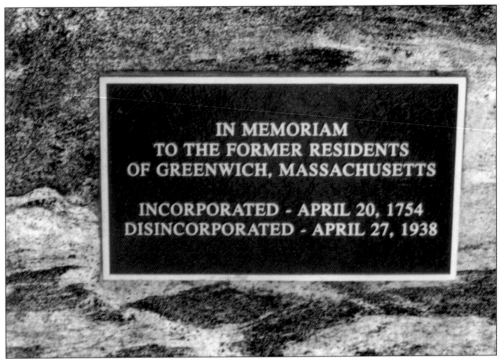

This plaque is mounted on a boulder selected from Greenwich and can be seen in the Quabbin Park Cemetery. Harrison Thresher, a Greenwich native, is responsible for the memorial plaque placed here in 2000.

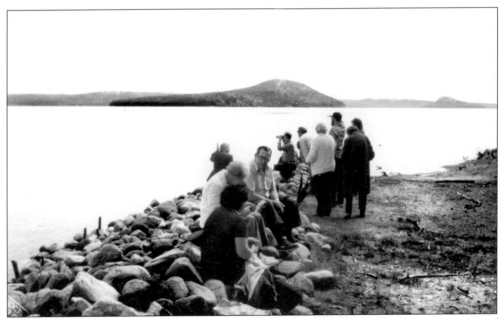

This group has just finished lunch while on a Prescott bus pilgrimage under the sponsorship of the Swift River Valley Historical Society.

As one of the last buildings demolished, the former Chandler House in Enfield stands alone. The house was used by the Metropolitan District Commission until 1938. The remains of the cemetery can be seen in the background.

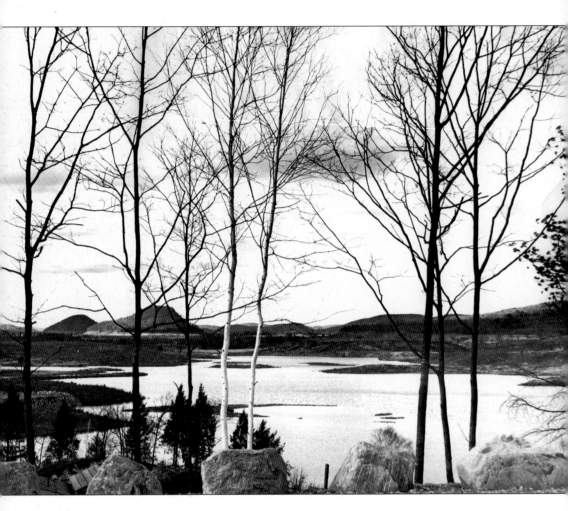

Now I have two beauties; one to remember and one to enjoy.

—Eleanor Griswold Schmidt